Ken Davies
Artist at Work

Ken Davies
Artist at Work

WATSON-GUPTILL PUBLICATIONS/NEW YORK
PITMAN PUBLISHING/LONDON

First published 1978 in New York by Watson-Guptill Publications,
a division of Billboard Publications, Inc.
1515 Broadway, New York, New York 10036

Library of Congress Cataloging in Publication Data
Davies, Ken, 1925–
 Ken Davies, artist at work.
 Includes index.
 1. Davies, Ken, 1925– 2. Photo-realism.
 3. Painting—Technique.
ND237. D32A4 1978 759.13 78-17520
ISBN 0-8230-2578-0

Published in Great Britain by Pitman Publishing,
39 Parker Street, London WC2B 5PB
ISBN 273-01281-9

Manufactured in Japan

First printing, 1978

To Maryann, whose typing fingers and temper are both shorter now than when I started this project.

Sincere thanks to my senior editor, Marsha Melnick, who for the last fourteen months has patiently and skillfully guided me in the writing of this book. Thanks also to Bonnie Silverstein, who edited my manuscript with a smile and a very deft pencil!

Contents

Introduction

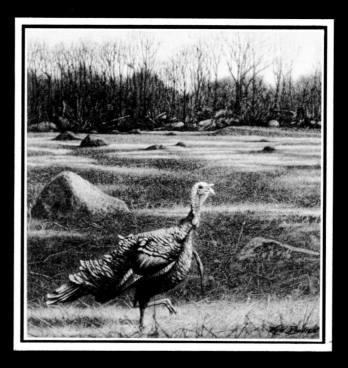

This book is about "what," "how," and "why" — what do I paint, how do I paint, and why do I do it? What I paint is extensively illustrated throughout the book in the many black and white and color plates. How I paint is presented in the detailed step-by-step demonstrations showing the development of six of my recent pictures.

Of the three questions, "Why do I do it?," is, of course, the most subjective. The more I think about it, the more intrigued I become with trying to answer it. In each of the six demonstrations in this book, I indicate why I became interested in that particular subject, what triggered my initial desire to paint it, and so on. This was relatively easy to do, as it applied directly to the work under discussion.

But when I started to think in more general terms as to why I have painted almost exclusively in this manner for the last thirty-one years, I began examining a little more closely the thoughts and events that have significantly affected my painting career. It occurred to me that anyone interested enough to read this book might also have some interest in a very brief, personal art history of the fellow who wrote it.

Major Milestones

I've done three pieces of work that were major milestones for me over the years. The first of the three was a drawing I did in the fourth grade. My teacher, Miss Sweeney, had decided to turn an art assignment into a class competition. I'm not sure why, but I decided to draw a cow. This "masterpiece" has long since disappeared, but I remember working very hard on it and when it was finished, I remember being very proud of it. I thought I had a rather elegant cow and that she stood a very good chance of winning a prize in the competition. My impatient wait for the results of the judging seemed endless but, finally, Miss Sweeney announced her decision — Ken Davies had won first prize! I was ecstatic. Up to that time, I had been just another dull little kid in the fourth grade, but now, with a mere sweep of my HB pencil, I was an overnight celebrity! This was pretty heady stuff, and it became obvious to me that my lifework would now be in art. The only career I had seriously considered before this auspicious moment was that of a garbage man. (I was very impressed with the trucks they drove.) But now, here was something that excited me even more. Thanks to Miss Sweeney's impeccable judgement, the art world was about to be invaded by the best artist in the fourth-grade class at the H.A. Kempton School! That was how it really started, and since then I haven't had a serious

interest in any other career.

I painted the second significant piece of work in my freshman year at the Massachusetts School of Art in Boston. It was the first oil painting I ever did in my life. All through junior and senior high schools, I'd struggled unsuccessfully with both transparent and opaque watercolor. Since the art classes there didn't get involved with oil paint, it wasn't until my first year of art school that I was introduced to the medium. It was love at first sight. I had finally found a paint that could be manipulated—it stayed wet for hours, enabling me to blend colors and values, and to take my time doing it.

The first offspring from this love affair (as you can see in Figure 1) is not exactly the most magnificent oil painting in the world. But that was of minor importance, for I realized then I'd found my medium. Since then, except for two paintings in egg tempera, one in acrylics, and a few very early opaque watercolors, I've worked only in oil.

My third significant work was done in my junior year (1948–1949) at the Yale School of Fine Arts. The title is *Lighthouses in the Alps* (Figure 2). This was the painting that definitely determined I was going to be, first, a realist, and second, primarily a still-life painter. It also

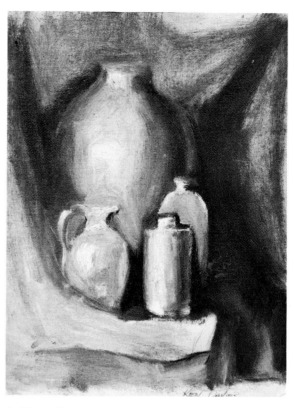

1. First Painting. *(Above) Oil on canvas board, 9" x 12" (23 x 31 cm). Collection of the artist. The instructor had a large table loaded with all kinds of jugs and bottles and we could select whichever ones we wanted to paint. I worked on it for three hours. I don't remember what grade I got on it but it didn't matter—I knew I'd found my medium.*

2. Lighthouses in the Alps. *(Right) Oil on canvas, 30" x 38" (76 x 97 cm). Collection of Mr. and Mrs. William G. Newton, Jr. This is the painting that determined how I'd paint for the rest of my career (or at least the next thirty years). It was done in my junior year at the Yale Art School. The piece of driftwood started it and from there it just grew and grew. The Punch puppet is left over from my junior high and high school days when I used to give magic and Punch and Judy shows. The $11 bill was painted here in deference to the Treasury agents, who seem to have an aversion to people painting real $10 bills.*

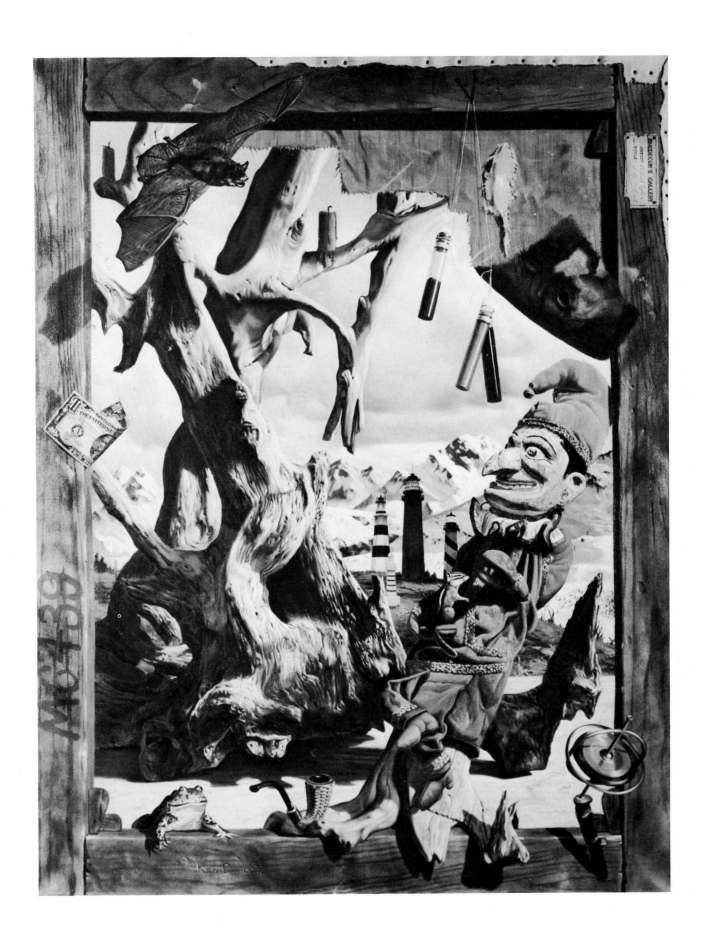

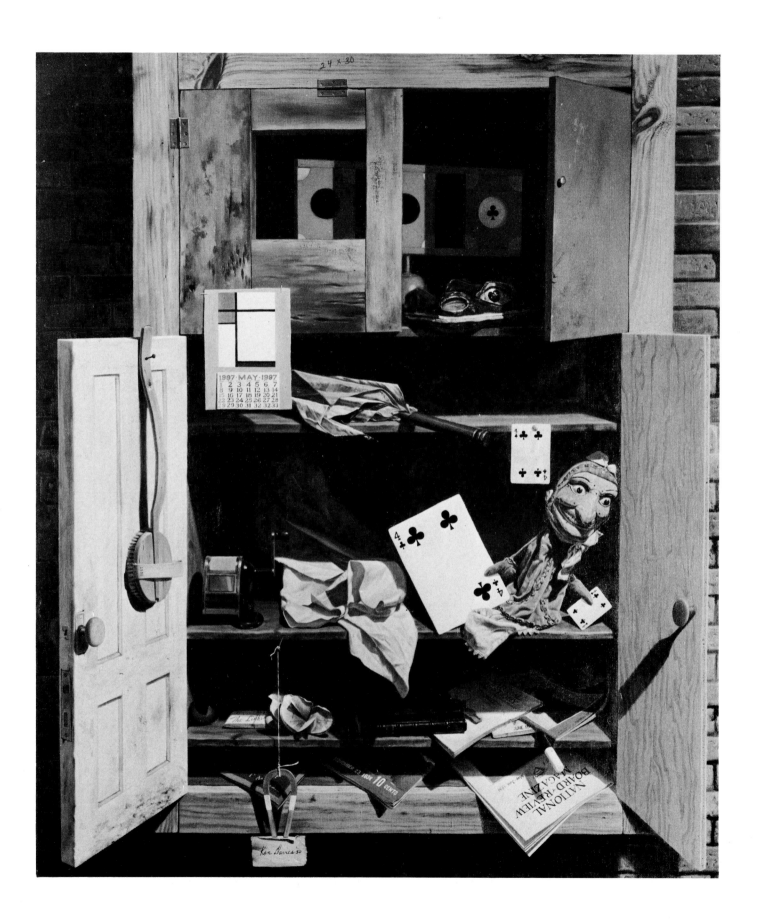

sparked my interest in *trompe l'oeil* effects (my thesis for the B.F.A. degree at Yale was written on the history of trompe l'oeil painting). I did the painting with tongue in cheek, strictly for fun, intending no deep significance or symbolism. However, some years later, the now-defunct *New York Herald Tribune* reproduced the picture in their Sunday magazine section, along with comments and criticisms from a mixture of psychiatrists, psychologists, museum directors, and art critics. When they got through dissecting the painting (and me), I suppose I should have headed immediately for the nearest mental institution. But instead, I stuck my tongue further in my cheek and quietly thanked the *Tribune* for not also reproducing *Pocusmania* (Figure 3), the painting that followed *Lighthouses.*

The compositions of these two pictures, and of most of my early paintings, are quite different from my more recent ones. My early paintings are very cluttered and busy. I've since removed the tongue from my cheek and become more interested in simpler arrangements, stronger value patterns, and combining abstract shapes and designs with very realistic renderings. I feel that this gives me the best of two worlds. I hope that my work now has a sound abstract composition and at the same time entertains the eye, upon closer examination, with its realistic detail.

3. Pocusmania. *Oil on canvas, 28" x 40" (71 x 102 cm). Collection of the Springfield Museum of Fine Arts. This painting followed* Lighthouses *and was done in my senior year at Yale. It won me my first cash prize and was instrumental in my admission to the Connecticut Academy of Fine Arts in the early fifties. The cabinet is filled with many pieces of magical apparatus from my "show biz" days in high school. A Springfield newspaper once published the picture under the heading: "How many things can you find wrong here?"*

Wild Turkey Paintings

The "wild turkey" chapter of my career is not only interesting, but quite unique. In the first place, you might ask, "Why is an artist who is primarily known for still-life painting doing illustrations of wild turkeys walking and flying around in the woods?" That's also the question I asked myself back in 1965 when I was first asked to do some sketches for a Wild Turkey Bourbon advertisement. Here's what happened.

In those days I was earning my living, for the most part, by doing commercial art. I worked for the major New York advertising agencies, painting illustrations that appeared in the various national magazines.

One day back in 1963, I received a call from the owner of an

advertising agency, Charles Mosler. He told me that he had my reproduction of *The Bookcase* (Figure 4) on his office wall and had decided that I could help him solve a problem. He was having trouble getting a satisfactory photograph of a triangular bottle for one of his advertisements and had decided, instead of the photograph, to commission a painting of the bottle, and wanted me to do the job. I was intrigued with the project, so I went into New York to talk to him about it. We immediately developed a rapport, and since that day we've become very close friends. I accepted the commission, successfully painted the bottle, and subsequently painted another advertisement for the same account.

I didn't hear from Charles Mosler again for about a year and a half. Then in 1965 he called again. This time, he wanted a painting of a wild turkey! Unlike his first assignment, this one didn't intrigue me—and I told him so. I tried to explain to him that I was a *still* life painter, not a *wild* life painter. He listened patiently and then insisted that I at least come in to New York again and discuss it with him. I finally agreed, mainly because I enjoyed him and his great sense of humor. I had no intention of accepting the assignment.

When I arrived at his office, he explained that he needed a painting of a wild turkey to be used in a new advertising campaign to promote Wild Turkey Bourbon. At that time, I hadn't heard of Wild Turkey, I'd never seen it in a package store, I'd never seen it in a restaurant, and I'd never seen an ad for it. He proceeded to outline his planned campaign based on a painting by yours truly. (He's a very convincing fellow but I was more than prepared with my counterattack.) A very good friend of mine just happened to be having a one-man show in New York, and I convinced Charlie that he and his art director should visit the show. I was certain they'd agree with me that my friend was exactly the artist they needed to paint their illustration.

After they patiently listened to my argument, the three of us walked over to the gallery on Madison Avenue and looked at the exhibition. I watched them both as they carefully studied each picture, and was satisfied that they were properly impressed. We finished looking at the paintings and walked out of the gallery with neither of them saying a word. Finally, I looked at Charlie and asked, "Well, what do you think?" He looked right back at me and, without a moment's hesitation, announced, "I want *you* to do the

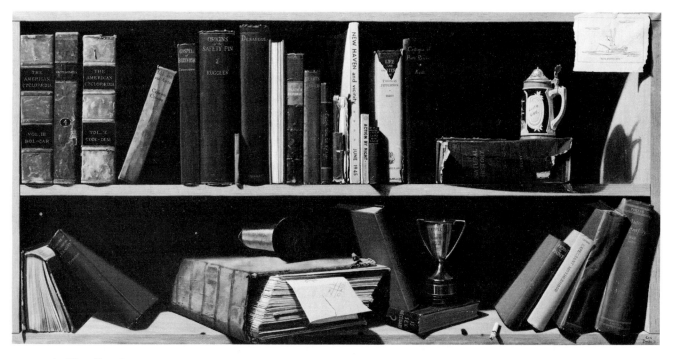

4. The Bookcase. *Oil on canvas, 22" x 38" (56 x 97 cm). Collection of the Wadsworth Atheneum. This painting was done during the first year after my graduation from Yale. It was one of nine reproduced later by Triton Press, Inc., in New York. One of these Bookcase reproductions hanging on the wall in an advertising executive's office was actually responsible for my getting involved with the* Wild Turkey *paintings.*

painting." His art director agreed.

I was flabbergasted! I was also beginning to think these two fellows had been working so hard that their judgment had become impaired. Little more was said until we got back to the office. By then I was beginning to recover from the shock. In addition, I began to realize that I was outnumbered by the "enemy" two to one, that I was alone in their office, and that I'd just played my trump card and had lost! My defenses began to crumble and I began to panic. Now Charlie Mosler is a real pro at this game and he had

saved his most telling arguments until the end. At this point he brought up his heavy artillery and fired the following four salvos at me in rapid fire order: (1) I would have complete freedom to paint whatever scene I wanted. Their only requirement was that it had to have a wild turkey in it. (2) There would be no deadline. I could have as much time as I wanted. (3) They would supply me with all the reference material I needed, including a stuffed bird *and* a lengthy movie showing the turkey in action. (4) He'd take me out right then and there and buy me lunch,

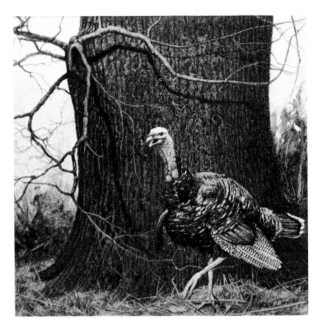

5. Strutting Bird. *Oil on illustration board, 7" x 6¾" (18 x 17 cm). For many years I eyed this wonderful old tree, which is not far from my home. The thing that intrigued me most was the strange twisted branch growing out the side of this huge trunk. I had been looking for the right painting in which to use it for some time. When I started this series of turkey sketches, I realized the time had arrived. It made a perfect background for this very "self-confident gobbler." I especially like the stark contrast of the white and red head against the dark mass of the tree trunk. The expression on this fellow's face leaves no doubt that he has no intention of ending up on somebody's Thanksgiving dinner table.*

preceded by a Wild Turkey on the Rocks!

Needless to say, at this point, my surrender was imminent. He then delivered the *coup de grace*. Mr. Mosler was not only the owner of the agency and the account executive in charge, but he was also the advertising manager for the client, Austin, Nichols & Co., Inc. In effect, he was his own customer! We signed the surrender papers at lunch about half an hour later, and a long, pleasant relationship with a famous American bird had begun.

A few years ago Charlie retired; the account is now handled by Nadler & Larimer, Inc. Luckily for me, the people there have been friendly and cooperative. My relationship and the arrangement with them continues exactly as it began twelve years ago. Any artist who has ever worked with advertising agencies and commercial art will more than appreciate the rare opportunity I've had to paint what I want, and with *no* deadline.

You'll find two of my wild turkey paintings in the Gallery, on pages 132 and 133. The latest and probably the most well-known one is the flying bird, which has been used in Austin, Nichols ads for Wild Turkey Bourbon for several years. It even appears on the label

of their new Wild Turkey Liqueur.

In addition to the magazine ads, the paintings have been reproduced on billboards all over the country and I always do a pleasant little double-take when I run into one. I've seen them on the freeways in California, on the "strip" in Las Vegas, at Tampa and Palm Beach in Florida, and on the train going into New York City.

Recently I delivered several new studies to Austin, Nichols for the next painting. At the time of this writing, the one they'll use has not yet been selected. You'll find two of the studies I submitted reproduced here (Figures 5 and 6).

Through all the years I've been involved with this account, I've had only one problem: I constantly have to put up with my friends' and colleagues' teasing me that the most successful commercial painting I've ever done turned out to be a "turkey!"

Plan of the Book

So much for the story of my life. Now, to get on with the book. Next I'll discuss the materials I use, my studio setup, and my painting procedures. Then you'll observe the step-by-step growth of six recent pictures and finally there'll be a "one-man show" of several of my paintings, with comments on each.

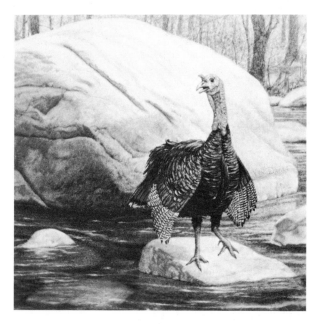

6. Wild Turkey on the Rocks. *Oil on illustration board, 7" x 6¾" (18 x 17 cm). After being somewhat surprised in learning of the wild turkey's ability to fly at high speed (he's been clocked at speeds up to fifty-five miles per hour), I was even more surprised to find out that he could also swim! Not a usual practice, but he can do it. That fact made me decide to do a sketch of a bird near or in a stream, and this painting was the result. This fellow may not be about to take a dip, but I'm sure he's about to take a refreshing drink.*

Materials and Methods

My studio is a very pleasant room in which to work. It has a fieldstone fireplace on one end and a door that opens onto a screened porch. The fireplace warms me in the winter; the porch cools me in the summer. The room measures 12' x 24' (4 x 7 m). I wish it measured 24' x 24' (7 x 7 m). Even though I paint relatively small pictures, I could still use twice the space.

Studio Setup

In addition to items such as my easel, taboret, and light table, I need room for my record and tape collection, and my stereo system. This is a must, since the first thing I do before picking up a brush is turn on the stereo. I need another large area on the floor right next to my chair, too. This space is reserved for my Great Dane (Figure 7), who insists on being no more than three feet (1 m) away from me at all times! As a result of all these space requirements, I intend to enlarge the studio within the next year or so.

My immediate work area contains an easel (Figure 8), a taboret on my right (Figure 9) and a shelf on my left for a projector and slide viewer (Figure 10). Nearby is my light box, where I can view as many as eighty-four 35-mm slides at one time (Figure 11). Over the years, many paintings have been born on that light box. This, of course, brings up the old argument about painting from photographs—I'll deal with that controversial subject in some detail a little later. Between the taboret and the easel, I have a small table on which I place my palette. This minimizes the distance between the palette and painting surface. In back of this table, to the right of the easel, I place the objects or setup to be painted (Figure 12). I like to keep them as near as possible so that I can study their detail at close range.

On the taboret, I keep my paint tubes, brushes, bottles of medium, varnish, a jar of turpentine, paint rag, and an old telephone book. I clean my brushes on the pages of the book, then simply tear them off and throw them away. This prevents both the rag and the jar of turpentine from becoming overloaded with used paint. Figure 13 shows an overall view of my immediate work area.

7. *My dog Dane, doing what he does best.*

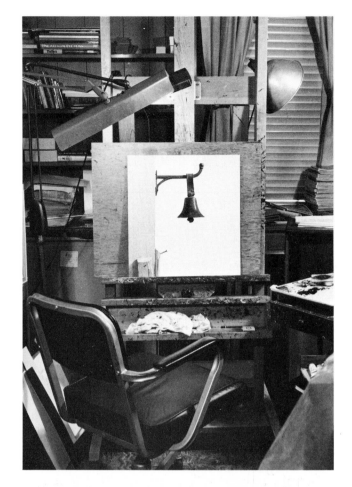

8. *(Right) My easel is the sturdy wooden type that rests on lock casters and is equipped with a crank handle for raising and lowering the painting.*

9. *(Below) The homemade taboret holds tubes of paint, a paint rag, brushes, a jar of turpentine, bottles of varnish, linseed oil, and an old telephone book. I use its pages to clean the excess paint off my brushes.*

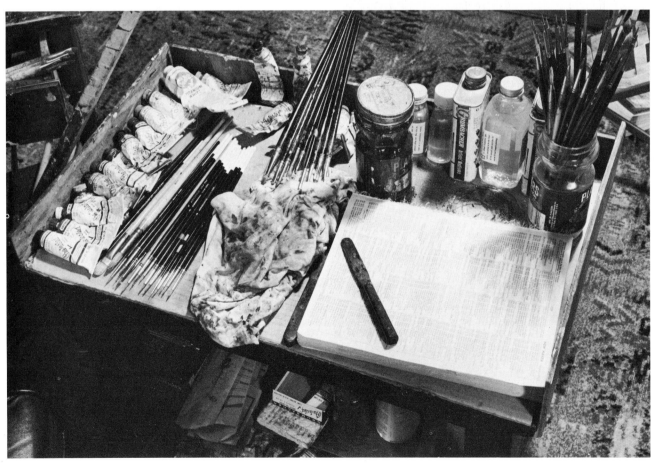

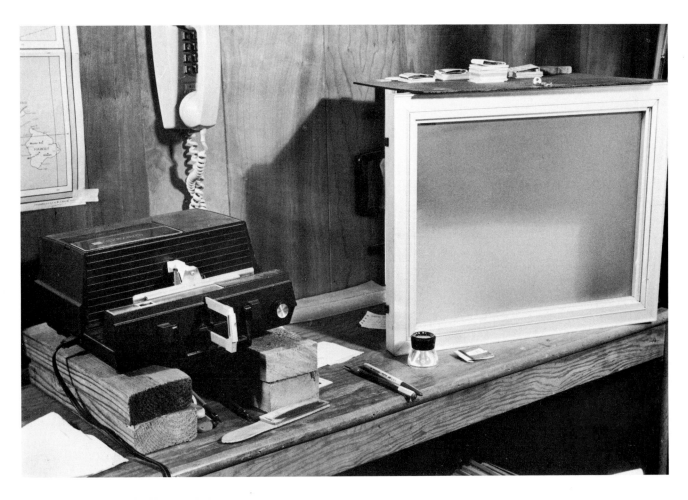

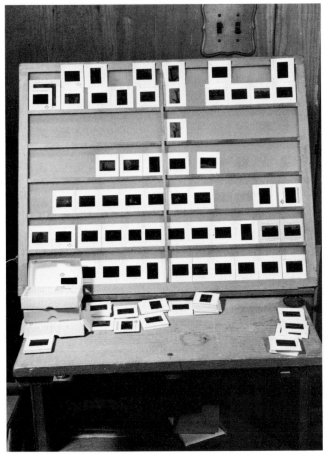

10. *(Above) This is my slide projector and viewing screen. The screen measures 16⅜" x 12" (41 x 30 cm), and provides a large viewing area for examining slides.*

11. *(Left) Many slides can be examined at once on this light box. Under the box are three storage shelves.*

12. *(Left) I keep this stand just to the right of the easel. On it, I place the object that I'm painting at the moment. I want it as near as possible in order to study the detail at close hand.*

13. *(Below) Here is an overall view of my immediate work area.*

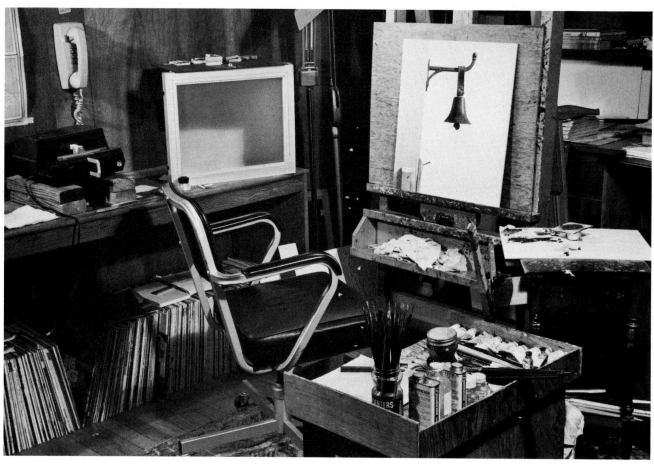

Lighting

As I mentioned in my first book, *Painting Sharp Focus Still Lifes*, I prefer not to use the traditional north light. In fact, my studio faces west and I have the shades drawn to keep the natural light out. To me, north light is much too inconsistent. On a sunny day it's blue, and on a cloudy day it's neutral. At five o'clock in July it's bright, and at five o'clock in December, it's nonexistent. For these reasons I prefer the constant light of a neutral fluorescent bulb. I light my setups, on the other hand, with an ordinary incandescent one-hundred-watt bulb. This gives the pleasant, warm glow that I prefer. The business of lighting does get a little tricky, however. You can never be sure just what kind of light a painting will eventually be viewed under. Most galleries use a relatively warm light, while office buildings generally have cooler fluorescent lighting. In private homes, it can be even more complicated. During the daytime, a painting may be on a wall illuminated by cool natural light; but at night, most homes have warm incandescent light. All this obviously presents a problem when trying to decide which light to paint under. I've found that a painting done under warm light tends to look gray and "dead" when viewed under natural or fluorescent light. On the other hand, I feel that a picture painted under neutral fluorescent light is generally enhanced by a warm spotlight or an incandescent bulb, but also holds its own when viewed under cooler daylight. I try to strike a happy medium between the two by frequently examining a painting in progress under both lighting conditions.

Brushes and Knives

Ninety percent of the time, I use small sable brushes. I use larger bristle brushes primarily for blocking in large areas and achieving certain textural effects. The shapes of my brushes are pointed, flat, and filbert. When a sable brush wears down, I don't throw it away—the smaller ones are used for blending edges and the larger ones are used for blending bigger areas. Figure 14 shows my complete set of brushes. I use palette knives primarily for mixing large amounts of paint to cover the bigger areas during the wash-in and block-in stages.

Painting Surfaces

I paint on only two surfaces: ¼" (13mm) untempered Masonite panels coated with gesso, or a good-quality 100% rag paper mounted on double-thick board

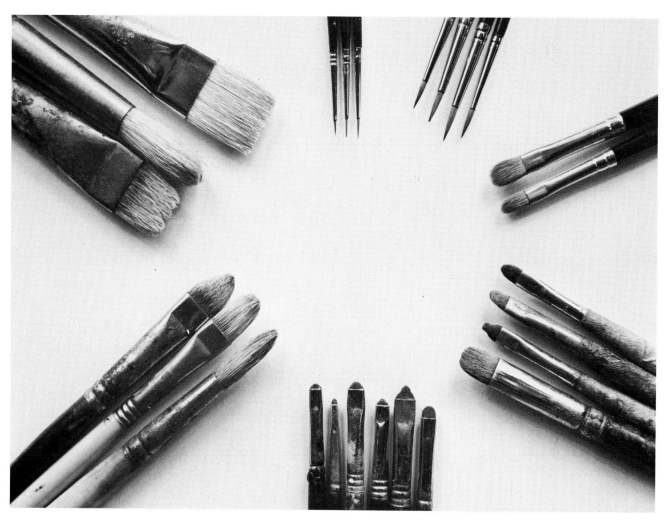

14. *These are the brushes I use most frequently. Starting at the top and going clockwise: three small no. 1 sables, four pointed sables nos. 5 and 8, two new filberts, four filberts used primarily for blending small areas, six very worn filberts for softening edges, three medium-sized bristles, and, finally, three large bristles.*

(commonly referred to as illustration board). My large major paintings are always done on Masonite, and smaller, looser works are done on board. Although I now have no preference for any particular brand of illustration board, in the past, Whatman board (which is no longer being made today) was a favorite.

To prepare the Masonite for painting, I first sand it with a medium-rough sandpaper. Then I apply one coat of gesso to the back of the panel and usually two coats to the front using a flat 1-in. (2.5-cm) bristle brush. The final coat is not sanded smooth because I prefer the very slight texture that is produced by the bristle brush—it comes in handy for producing "happy accidents" during the wash-in stages. There's an exception to this "no sanding" rule, though. If I'm painting extremely fine detail on a smooth surface (such as a piece of paper with type on it), I'll sand just that area smooth, since even the texture created by brushing on the gesso gets in the way of such small detail.

When I work on illustration board, I usually first brush on a coat of retouch varnish over the drawing. This seals the surface somewhat and helps prevent the wash-in from sinking into the paper.

Colors

My palette consists of the following colors:

Cool	*Warm*
Ivory black	Cadmium yellow light
Ultramarine blue	Yellow ochre
Cobalt blue	Cadmium red light
Cerulean blue	
Viridian green	Cadmium vermilion
Permanent green light	Cadmium red deep
Sap green	Alizarin crimson
Titanium white	Burnt umber
	Burnt sienna
	Raw umber

This is pretty much the same selection of colors that I've used since I started painting. I prefer titanium to other whites because it is "whiter." The only color that has been added since my art school days is sap green. I think it's a very handsome, rich green and very useful for grass and foliage. The selection of colors for a palette is, to me, a very personal matter. I've tried many different ones over the years but have found that, with very few exceptions, this list enables me to mix any color I need.

Only one exception stands out

vividly in my mind. Many years ago while doing a commercial ad, I had to match the color on the carton of a product. It was an unusual blue-violet color, and the surface of the box was covered with a suedelike texture that caused the color to vary slightly under different lighting conditions. After trying every possible combination of my usual reds and blues, I was frustratingly far from duplicating that particular shade of violet. In desperation, I finally went to the art shop and bought a tube of every blue, every red, and every violet color they had in stock! Eventually after much more trial and error, I was satisfied with the mixture, but it was a most frustrating experience. That's the only time I ever used those tubes of paint, and they have long since either dried up or have been given away.

As you'll discover later on in the Demonstration section, the colors I use most are the umbers, siennas, and cobalt blue. Black is the least-used color. In fact, I've had a tube of black for fifteen years or more, and it's still half full. For darks, I prefer working with a mixture of burnt umber and ultramarine blue, which is almost as dark as black.

Mediums and Varnishes

Most of the time I use a mixture of linseed oil and damar varnish as a medium ($\frac{2}{3}$ linseed and $\frac{1}{3}$ damar). During the preliminary wash-in stage, I generally add a little turpentine to this mixture so it isn't so rich. It also helps speed up the drying time of the wash-in, since a lot of medium is used at that point.

While I'm still painting, when the darker colors dry, they have a tendency to go matte or "dead." To restore their original value and color, I brush on a thin coat of retouch varnish. But I do this only when it's absolutely necessary, in order to avoid a buildup of alternating layers of varnish and paint.

As a final varnish, for years I have brushed on a mixture of damar and matte varnish. Straight damar varnish gives the surface of the painting a much too slick, glossy appearance, and I prefer a semi-gloss effect. At present, after talking with several professional restorers, I'm leaning toward switching to a synthetic varnish and having a restorer spray it on.

Ideas

Inspiration for a painting can come at any time and at any place. The unpredictability of it all adds spice and excitement to the procedure. Generally, my painting ideas come from two main sources: specific props or a combination of props and picture-taking rides around the countryside.

Cluttered antique shops are my favorite source of props. For me, just to browse through one of these stores is an exciting adventure. Sometimes an object will immediately suggest a painting, and other times, I'll buy an item for its shape or texture and not have any idea when or how I'll eventually use it—it's often several years before it gets included in a picture. You can see a random selection of the props I've used in several different paintings in the photograph on page 29. The two white objects in the right center area appeared on the cover of my first book, *Painting Sharp Focus Still Lifes*.

In addition to visiting antique shops, I love to spend a day just driving around backroads and stopping to shoot pictures of whatever attracts my attention on that particular day. I have literally hundreds of slides taken over the years, and periodically I review all of them. I'll often run across a shot taken many years ago that I've seen dozens of times, and suddenly get an idea for a new painting. Often I'll see something either in or outside of my house that sparks an idea. The subject of Demonstration Six, *Kitchen Potbelly*, is one such example.

Composition

There's an almost unlimited supply of information on composition available. Innumerable books have been written on the subject, and art schools have an overabundance of composition classes. There are classic rules of composition to abide by if you're so inclined, and every artist I've ever talked to has had his or her own personal opinion as to what is good and bad composition!

Long ago, I realized that there's no such thing as universal "good" or "bad" arrangement in a painting. It depends entirely on the personal preferences of the painter or the spectator. So, I long since stopped thinking about so-called "rules" of composing. I once asked one of the students in my class why he'd arranged a certain picture the way he did. Without a moment's hesitation he answered, "Because it felt right." The more I think about his answer, the more I realize that his four-word reply just about sums up the subject of composition for me.

I may spend a great deal of time arranging and rearranging objects in a setup, trying different combinations of props, and experimenting with different lighting positions before the whole thing "feels right." Other times, I know exactly what I want ahead of time and it "feels right" immediately. I realize that all the rules of composition that I learned back in art school are still in the back of my

mind (and I think *should* be), but I no longer consciously refer to them or apply them.

The length of time I spend on a painting varies. An average painting takes between 100 and 150 hours to paint, but I've painted "quickies" in as little as three hours, while some paintings have taken as long as 350 hours.

Photography

Should an artist use a camera as one of the tools of his craft? That's a question that has sparked much discussion and controversy over the years. Some artists adamantly refuse to use photography, and others unhesitatingly take advantage of it. I obviously am in the latter category.

I personally think the camera, *if used correctly,* can be one of the artist's most valuable tools (that goes for abstract painters too — not just realists). The phrase "if used correctly" is *extremely* important! In the hands of an amateur painter who doesn't know how to draw and paint, doesn't have a *thorough* understanding of perspective, and is unaware of the limitations of photography, a camera can be a deadly weapon. I've seen some extreme examples of this lack of knowledge, and the results are both tragic and ludicrous.

In my opinion, no serious artist should paint from photographs until he or she has had *extensive* training in drawing, painting, and especially, perspective. A good rule might be: "If you can't draw it, don't photograph it!" Once you become proficient in these subjects, you can think about making a trip to the camera store. Purchasing any good-quality 35mm camera is, I think, a good starting point. I've found that, in addition to the basic camera, both a wide-angle lens and, especially, a telephoto lens come in handy.

My first rule when shooting is: don't try to conserve film. When I find a promising subject, I shoot it from every conceivable angle. I also shoot closeups for detail and (very important) make separate exposures for large shadow areas so I can see the detail in them. It's very frustrating to get back to the studio and find you don't have enough information to complete a painting — especially if the subject is several hundred miles away.

Two of the demonstration paintings later in the book would not exist without the use of photography, since the main subject in each picture — the old cabinet in *Tea Break* and the antique wooden bellows in *Bellows* — was borrowed and had to be returned long before the painting was completed.

One of the most obvious advantages of the camera is appar-

ent when the subject is outdoors and illuminated by sunlight. When I find a fascinating play of lights and shadows on the side of a building, for instance, I can capture the moment permanently on film. If I had to sit there and make studies (either drawn or painted), I'd have to be lightning fast, because that particular set of lights and shadows would stay like that for only a few moments.

Using slides also permits me to do the actual painting in the stu-dio and not outside. I can do without the curious passerby who has to look over the artist's shoulder and make appropriate comments about how his Uncle Ed is also an artist. And finally, in the comfort of the studio, I don't have to contend with leaves, dirt, or bugs falling into my paint. (It's true that in my studio I often have a friendly Great Dane looking over my shoulder, but he never makes any comments about my work *or* his Uncle Ed!)

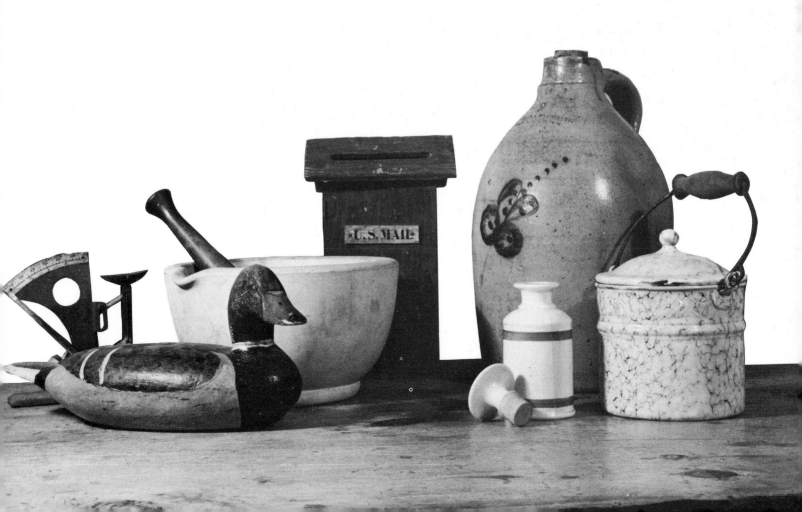

Demonstration One

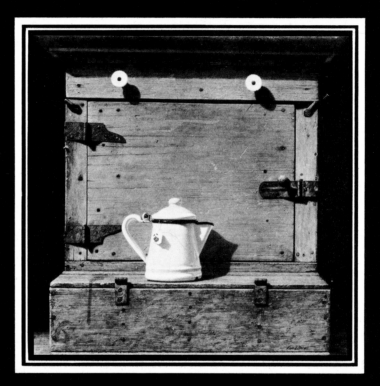

Tea Break

Like many of the props that appear in my paintings, the old cabinet and little white teapot in this picture were borrowed from students at the Paier School. One of the fourth-year illustration students, Anthony Kramer, had used the teapot for a rendering assignment and it caught my eye. I knew I wanted to use it but did not have anything specific in mind at the time.

Shortly after, I was leaving my office one day for lunch, and as I passed by the reception area, I came face to face with this wonderful old cabinet. Standing behind it, with a big smile on his face, was a fifth-year scholarship student, Mark Keigwin. Two years before, he had painted several of the illustrations used in my first book, *Painting Sharp Focus Still Lifes*. As a result, he was quite familiar with the kind of prop that would excite me, so he couldn't wait to show off his latest discovery. I knew immediately that I wanted to paint it. He was very kind and agreed to loan it to me, but since he wanted to do a painting of it himself, I photographed the cabinet so I could return it to him promptly. I shot almost a whole roll of film (thirty-six exposures) to make sure I had enough information to complete the painting. This included many closeup details of different sections, such as the hinges, knobs, latch, and so on. Of course I much prefer to have the actual prop in front of me throughout my work on the painting. However, when that can't be done, I've found from experience it's far better to have too much information than not enough. Consequently, I indulge in a little "overkill" with the photography. For instance, in addition to closeup details and normal exposures, I usually take an overexposed and an underexposed shot of everything. The underexposed photograph shows the detail in the light areas, while the overexposed shot gives me the detail in the shadow areas. There's nothing more frustrating, while painting from photographs, than trying to see detail in either bleached-out lights or too dense darks.

While photographing the cabinet, my eye fell upon the little white teapot, and it didn't take long for me to realize that the combination of the two props suited my needs perfectly. Later I decided to add a teabag for a bit of interest. At first I intended to use the blank back side of the tag so as not to feature any one tea company, but when I saw that tiny spot of red against the white of the pot, which in turn was surrounded with the blue-green of the cabinet, I just couldn't resist it. To me, that little touch of color adds much to the finished product. With this, the composition was established.

The next step was to draw the setup on the gessoed Masonite panel (Plate 1). As you can see, I shaded in the shadows. This isn't necessary, but I sometimes do it to give me a quick feeling for the three-dimensionality, a quality so necessary to sharp-focus realism. It also helps add a little depth to the shadows during the wash-in stage. Plate 2 is a closeup of the teapot. Drawing a center line, as I do here through the middle of the cover, is standard procedure for me when drawing symmetrical objects (a method fully explained in my first book). Notice, in this case, that it's not vertical but very slightly tilted. The reason for this is that the cover didn't sit perfectly flat on the pot. With use, it evidently had become tilted off center. This is a very subtle point, but I feel it helps give a certain authenticity to the object. I guess most people wouldn't notice this in the finished painting. Notice also at this stage that the red rose is not on the teabag. It was added later, during the wash-in stage (Plate 3).

The wash-in is a very important step and takes very little time — it usually can be done in one day. The wash-in accomplishes several things: it covers the raw white of the gesso very quickly, giving an immediate impression of what the painting will eventually look like. It also establishes the color and value pattern, and pro-vides a basis for many textures.

Plate 4 is a closeup of the washed-in teapot, with the textured wood behind it. I produced this texture by dragging and dabbing a large bristle brush through the wet wash-in coat. This, of course, overlapped onto the teapot, and the white knobs and hinges of the cabinet, so while the paint was still wet, I carefully wiped off this overlap with a paint rag in order to re-establish the drawing. The overlap near the edges of the objects was wiped off with an old filbert brush.

Normally, I'd paint the background area on the sides and top of this cabinet a solid black void, but this time I decided to texture the background in order to make it more lively. I did this by rolling a large round bristle brush back and forth over the wet paint (Plate 5). When it was dry, I glazed the background much darker in value so the texture almost disappeared. The final glaze in that area is shown in Plate 6. You can also see there the three steps used in painting the wood: the door is still at the wash-in stage, the side and top are blocked in, and the top of the shelf is finished. In the block-in stage, I added a semi-opaque coat of paint on top of the wash-in. Notice how the original texture and nailheads show through slightly. In the next step I added the final detailing of the wood (Plate 7).

This is where I use the texture of the wash-in — keeping and emphasizing some parts and covering up others. Plate 8 shows the same area with the nailheads painted.

Plate 9 shows the sides and top of the cabinet finished, except for the glaze in the shadows. The door is still just washed-in. Notice that the shadows are considerably lighter in the finished areas than in the washed-in area. Plate 10 is a closeup of the upper half of the cabinet at this point, and Plate 11 shows the upper right corner.

In Plate 12, the door is finally blocked-in, along with the horizontal area at the bottom of the cabinet. This bottom area was very lightly opaqued since I was already pleased with the wash-in texture. I felt the texture on the door, however, was a little too monotonous so I gave it a heavier opaque cover. While painting this block-in, I used various mixtures of white, cerulean blue, raw sienna, and raw umber to vary the color.

In Plate 13, all the wooden sections of the cabinet have been detailed. The nailheads on the door and bottom horizontal strip still have to be added, but the cabinet is now ready for the next major step: glazing the shadows (Plate 14). In comparing these last two illustrations, notice the rather dramatic increase in the three-dimensional effect as soon as the shadows are added.

Plate 15 is a closeup of the latch in the wash-in step. You can still see some of the drawing underneath. In Plate 16, half of the latch has been blocked in with more opaque color, and Plate 17 shows the detailed finish.

I used this same procedure to paint the hinges. Plate 18 shows the washed-in hinge and Plate 19 the finish. In these two illustrations, compare the gaudy orange color of the wash-in with the more subtle grayed color of the finish. In Plate 20, the white knob has been rendered.

The painting is now complete except for the teapot. In Plate 21, the pot is shown all blocked-in (except for the black ridge under the cover and on top of the spout) and in Plate 22, the shadows have been glazed slightly, scratches and detail have been added, and the string and teabag have been completed. The finished painting is shown in Plate 23.

I was quite pleased with this painting and feel it is one of my better ones. As is my usual procedure, I delivered it to the gallery in New York unframed. They select the molding and arrange for the frame to be made, and it's usually two or three weeks before I get to finally see the finished product. In this case, the painting was sold before they had a chance to frame it. As a result, at this writing, I still haven't seen the total effect.

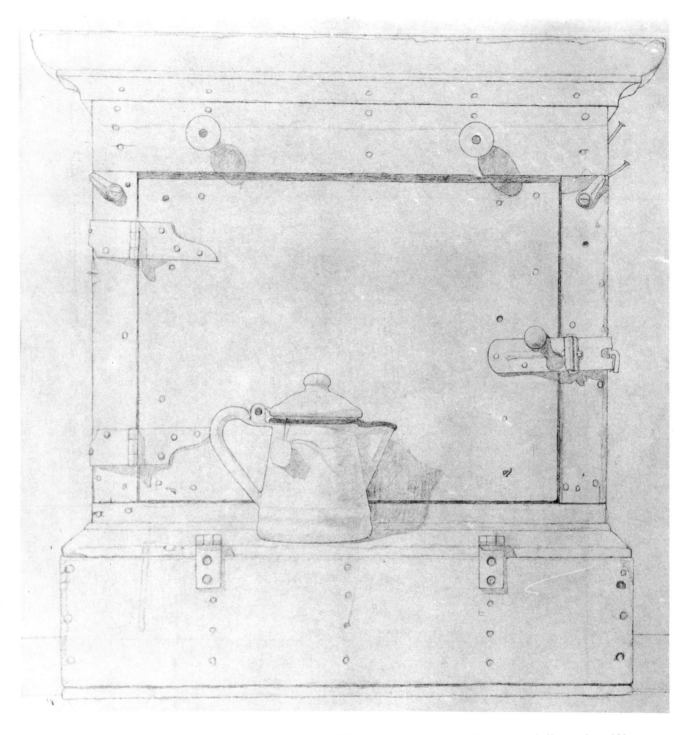

1. *I first do a complete drawing on gessoed Masonite panel, working carefully with a 2H lead pencil. I keep a kneaded eraser handy for cleaning edges and correcting mistakes. I draw everything, even the nailheads. But shading in the shadows is optional.*

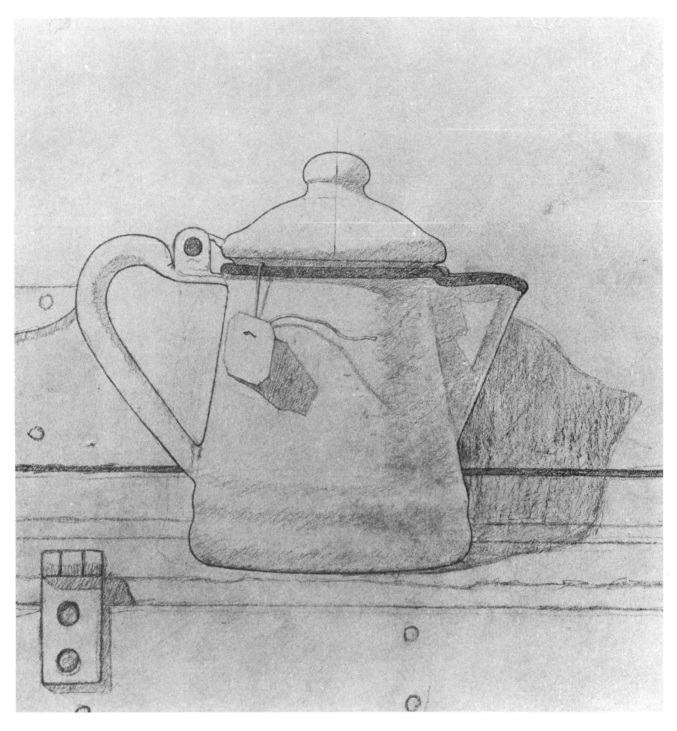

2. *In this closeup of the teapot, notice the precision of the edges around the pot. In sharp-focus realism, there can be no vagaries in the drawing — it has to be exact. Sometimes you may be tempted to leave a difficult part of the drawing less than perfect and "fix it when you paint." Don't — it's a lot easier to be precise with a pencil than with a brush.*

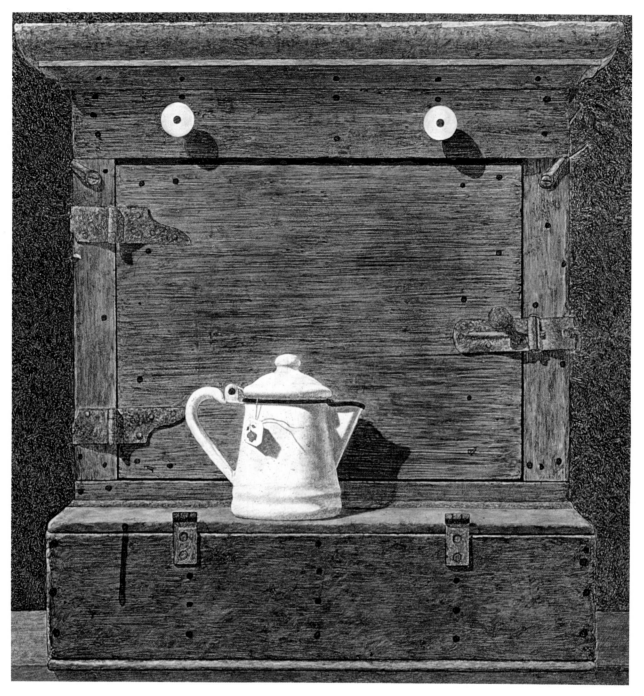

3. (Above) Next, I wash in the entire painting. The wash-in provides a quick way of getting a fairly accurate impression of the finished work. I can usually tell at this stage whether or not the painting will be successful. If it's not, it can be thrown away at this point with a minimal waste of time.

4. (Right) This is a closeup of the washed-in teapot. The paint is thinned to a transparent consistency with a mixture of turpentine, linseed oil, and damar varnish (about a third of each). The shadows on the pot are painted with a mixture of white, cobalt blue, and raw umber — one of my favorite mixtures.

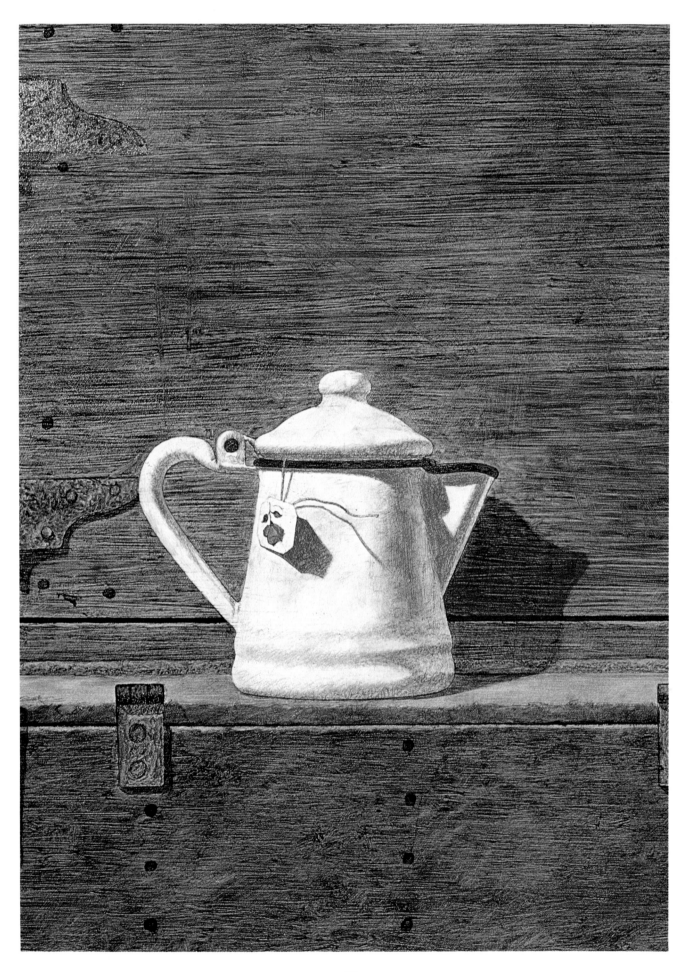

5. *Here is a closeup of the cabinet and the washed-in background area behind it. I painted the background with straight burnt umber and textured it with a large round bristle brush.*

6. *After the background area dries, I glaze its texture down in value with more burnt umber until the texture is just barely visible. You can also see the side and top of the cabinet here. To block them in, I scumbled semi-opaque color—a mixture of white, cerulean blue, raw sienna, and raw umber—over the wash-in of Plate 3.*

7. *Now I add the final wood texture over the block-in with a very small sable brush. I take advantage of some of the texture of the original wash-in, which shows through. I use cobalt blue and raw umber for the darks, and white, raw umber, cerulean blue, and a touch of yellow ochre for the lights.*

8. *I paint the nailheads, again using the white, cobalt blue, and raw umber mixture. I use very little cobalt blue—just enough to slightly neutralize the umber. On the more rusted nailheads, I add a slight amount of burnt sienna.*

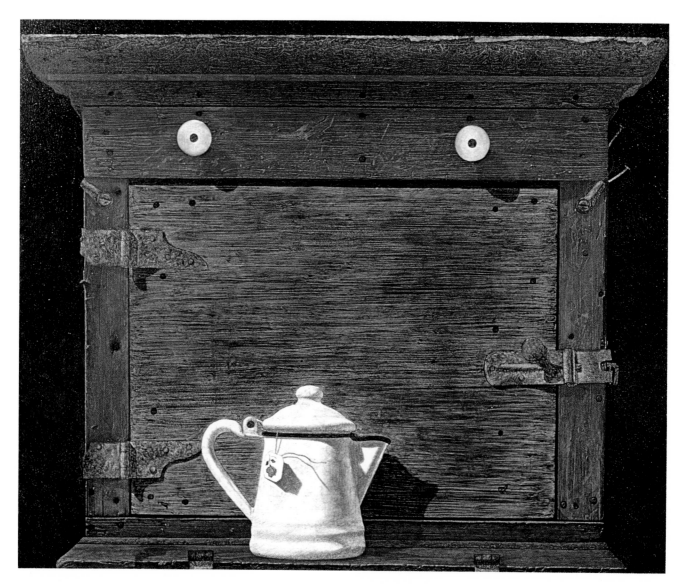

9. *The cabinet is now fully detailed except for the door, which is still only washed in. I plan to paint the worn top edge of the cabinet with dark and light accents where the wood is chipped, at a later stage.*

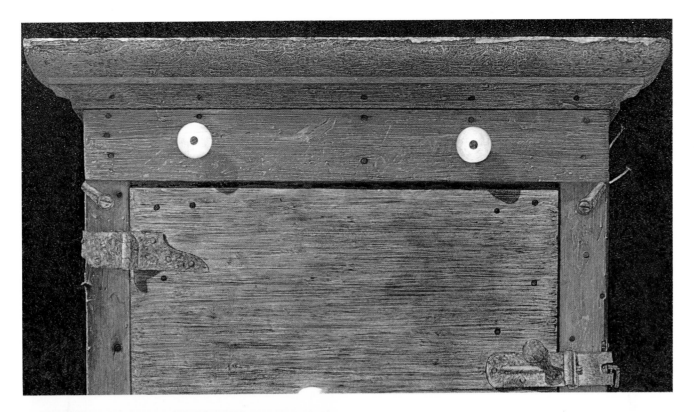

10. *(Above) This is a closeup of the upper half of the cabinet just before I glazed the shadows. You can see that the shadows on the finished areas are barely visible, while those on the washed-in door are much darker.*

11. *(Left) Now, the upper right-hand corner is finished and I'm ready to glaze on the shadows. The two nails sticking out from the side of the cabinet are only washed in. When I glaze on the background, these nails are, of course, covered, but they still can be seen through the transparent wash. So, while the glaze is still wet, I carefully wipe off the nails with a small, worn filbert brush.*

12. *The door of the cabinet is now finally blocked in. I applied a little more opaque color for this block-in since I felt the texture of the wash-in was a little monotonous. I'll add some of the texture on the door later by drybrushing color over this block-in.*

13. *The cabinet is now detailed and ready for glazing.*

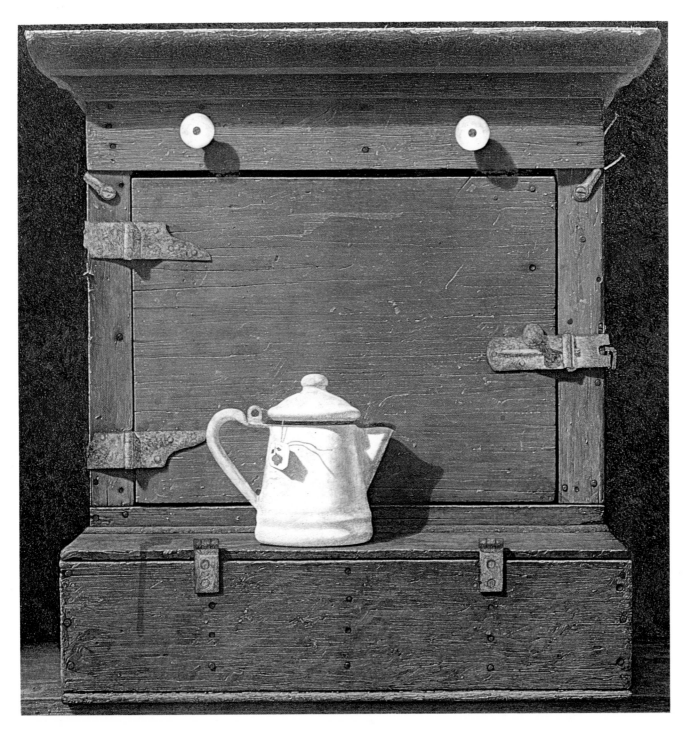

14. *I glaze the shadows with a mixture of cobalt blue and raw umber. I had expected to use some viridian green in this mixture, but when I found it made the shadows much too green, I eliminated it completely. By comparing this plate with Plate 13, you can see how the three-dimensional effect is increased when the shadows are glazed in.*

15. *Here is a closeup of the washed-in latch. I paint it roughly, with a transparent wash of raw umber warmed with burnt sienna in order to create texture. Some of the pencil drawing shows through the light wash.*

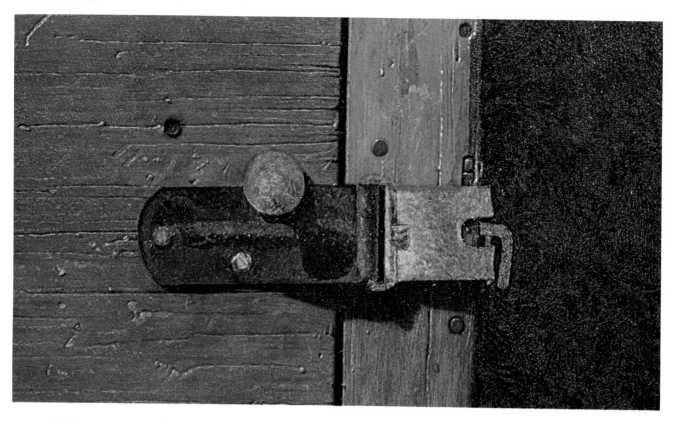

16. *I continue to block in the latch with more opaque color, using cobalt blue, raw umber, and some burnt sienna, which I combine with small amounts of white and yellow ochre to give it body. The blocked-in area is much darker and grayer than the wash-in.*

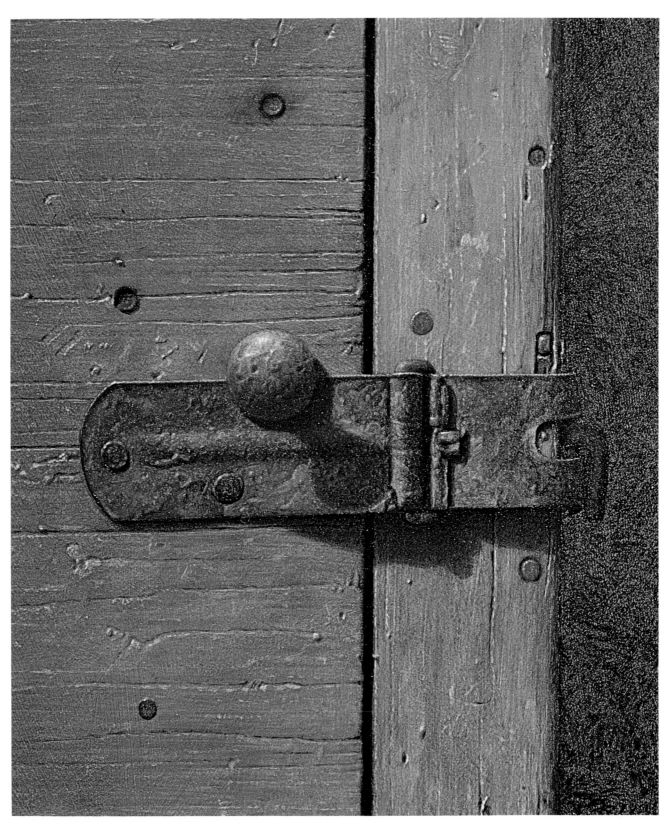

17. *After the colors are blocked in, I daub them carefully with a worn filbert brush to blend them. When this dries, I add the final highlights and dark accents of the final texture with a no. 1 sable brush. The latch is now finished.*

18. *This is how the hinge appears after the wash-in stage.*

19. *To finish the hinge, I use exactly the same procedure and colors that I used on the latch. The tiny highlights are not white, but a fairly dark mixture of white, yellow ochre, and raw sienna. They look lighter than they really are because of the very dark values around them. You can also see the blocked-in white knob in this figure.*

46

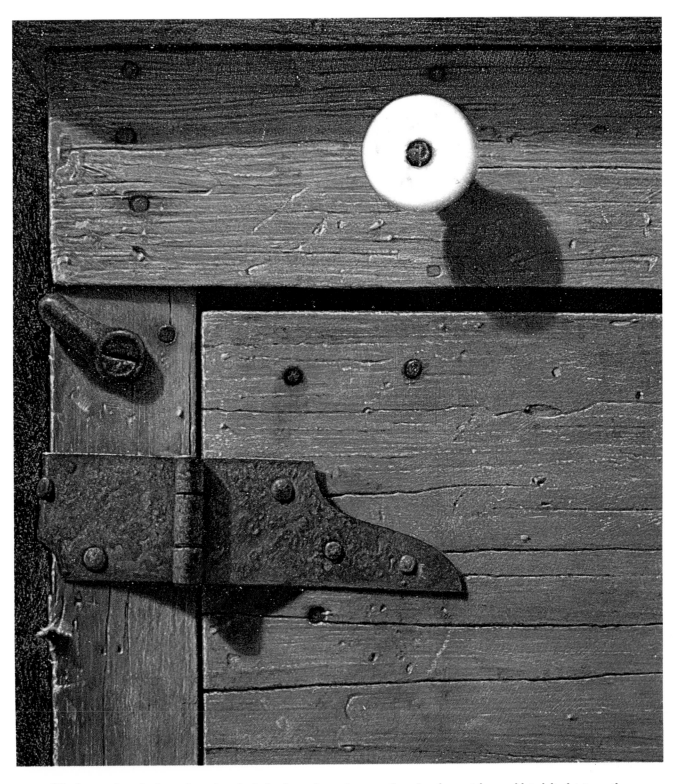

20. *I now finish the white knob. I darken the edge on the shadow side and highlight it on the light side. I texture it with subtle scratches and paint its metal center. I use burnt sienna for the slight bit of rust around the center. Once again, the white knob may look white but I actually paint it with a warm gray several values darker than white.*

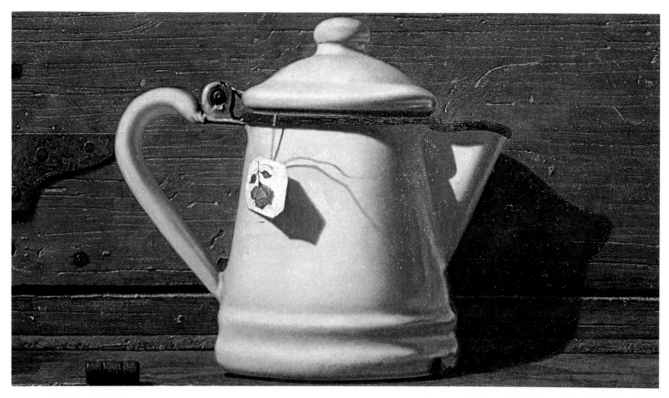

21. *I block in the teapot and blend all the shadows carefully by a combination of stroking and daubing them with a worn filbert sable. The shadows, at this stage, are very slightly lighter than in the finish.*

22. *To finish the teapot, I glaze the shadows just a shade darker. I add scratches, scuffmarks, and highlights to the surface and finish the string and teabag. The highlights on the little metal staple on the tag require the use of one of my smallest brushes — a 0000 sable!*

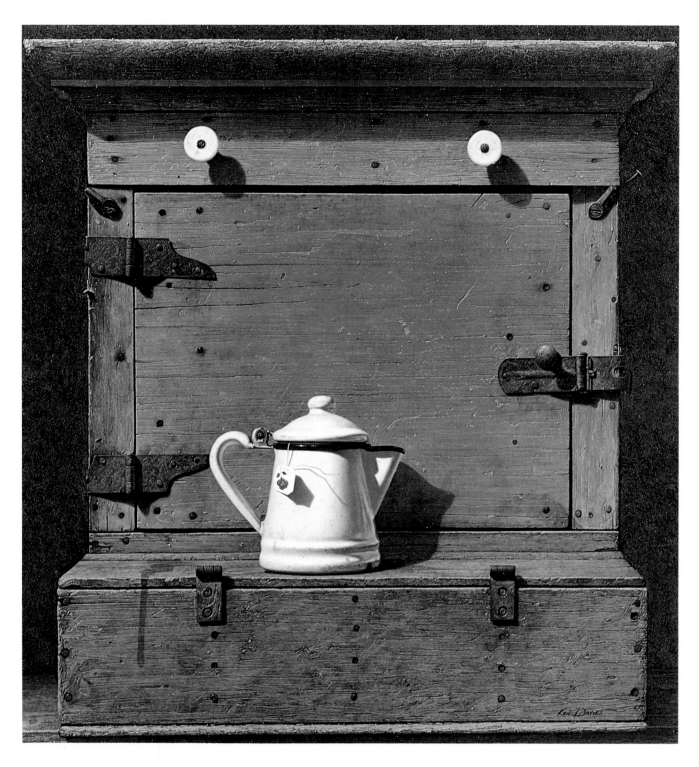

23. Tea Break. *Oil on Masonite, 22½" x 21½" (57 x 55 cm). Collection of John Quinn.*

Demonstration Two

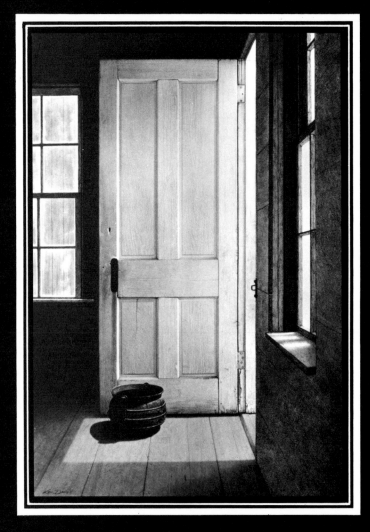

No. 6 at Sturbridge Village

Just north of the Connecticut border, in Massachusetts, is a wonderful place called Sturbridge Village. It was here that I found the subject for this next painting. Once inside the gate, you find yourself immersed in the middle of a working, early American village, complete with blacksmith shop, candle makers, farm, and all the other activities of early New England life. For someone like myself, who is interested in painting the many intriguing artifacts of the era, it's an irresistible attraction. Over the years, I've returned many times and in all four seasons, since it's open year 'round. Whenever I find friends who haven't been there, I have another opportunity to renew my love affair with the place.

The most recent visit was in June of 1976, when I showed it to friends from California. At that time, each building on the map of the village was numbered so you could easily find an area of particular interest. The tiny bootmaker's shop was no. 6 on the map— obviously the reason for the title of the demonstration. It was about 10 or 11 AM when we arrived at the shop. The door was open, the sun was just at the right angle, and so a painting was born. If we had started at the other end of the village and arrived at the bootmaker's shop in the afternoon, this painting would not exist.

As I've said before, this matter of timing is extremely fascinating to me. A given location or object can be uninteresting at one time of day but with some help from the sunlight, it can be transformed into a paintable subject at another time. This fact makes it advisable to investigate a potentially promising location several different times.

After noticing the door, I was preparing to photograph it when a gaggle of school children, complete with teacher and a few assorted mothers, descended on the building. Needless to say, my concentration was temporarily disrupted. While waiting for the mob scene to dissipate, I strolled down the path to another building, which ironically turned out to be the one-room schoolhouse. Luckily, the interest of grammar school children in an old bootmaker's shop is pretty short-lived, so it wasn't long before I could return and get the photographs I needed. If you should happen to be visiting Sturbridge on a June morning, I'm sure you'll see the door just about the way it is in the painting.

The iron pot was not in front of the door — I found it at another location in the village — but I added it as an extra point of interest. However, its addition caused me to make a rather foolish mistake. Here's what happened. At the time, the door itself was not

receiving any direct sunlight—just reflected light from the bright outdoors. Direct sunlight *was* hitting the floor, however, and in the original scene, this light area also had many cast shadows from the leaves of a nearby tree. Because I felt that this made the floor much too busy and interfered with the generally rectangular, geometric nature of the composition, I eliminated the leaf shadows. Then I added the iron pot, *together with its cast shadow*, to the painting. You can see the result both in the drawing (Plate 1) and the wash-in (Plate 2). A short while later, at the end of a painting day, while studying the progress and planning the next day's work, it suddenly dawned on me that if the sun were casting that shadow from the iron pot then it also would have to be casting a shadow from the top horizontal edge of the open doorway! This meant that the light could not possibly extend across the floor and out the left side of the picture.

I was mortified; this is just the kind of mistake I've berated my students about all these years. (I'm sure when many of them read this, a smile of revenge will appear on their faces.) To make matters worse, I obviously couldn't hide my mistake; the evidence was unmistakably there in the early step-by-step photographs, and by this time I was well beyond the wash-in phase of the painting. No, there could be no coverup. My carelessness would be recorded for posterity!

However, the mistake was quite easy to correct. All that I needed to do was to add the shadow cast by the doorway to the left of the iron pot. I added that when I glazed the shadows on the floor. (The correction first appears in Plate 11.) There was a positive result to all this, too. Once the shadow was painted, I was much happier with the design of the picture. I think the shadow shapes on the floor became more interesting and also more consistent with the rest of the composition.

Anyway, let's get back to the beginning. After the drawing was finished (Plate 1), I washed in the colors and values, as usual, over the entire painting (Plate 2). When the wash-in was completed, I realized that the texture of the back and side walls looked very much like what I wanted for the finished product. Plate 3 shows a closeup of this texture on the side wall and Plate 4 shows the back wall. Possibly, all that was really needed was the final glaze and the walls could be finished. This was one of the very few times when the block-in step might be eliminated. Since the back wall was in deep shadow anyway, the texture would all but disappear, so I decided to try a dark glaze on it (Plate

5). It worked very well. I knew the side wall would not be quite as simple but decided to try it when the time came to finish it.

The next step, though, was the back window. Plate 6 is a closeup of the washed-in window. The vertical boards visible through the window are on the building next door several feet away. At this wash-in stage, notice how those boards look as though they are in the same plane as the window itself. Also, there doesn't seem to be any glass in the window. I rectified this by painting a light, semiopaque wash over each windowpane. I then added lighter, more opaque, areas and, finally, the much lighter edges of each pane of glass (Plate 7). Next, I glazed the windowframes themselves down in value and finished the back window (Plate 8). It's interesting to compare Plates 6 and 8.

Plate 9 shows a closeup of the washed-in floor. Unlike the walls, this area needed a block-in coat, too. In Plate 10, the scratches and scuff marks on the floor have been added over the block-in coat. After the marks on the floor were dry, I glazed down the value of the shadows and in Plate 11, for the first time, you can see the corrected shadow cast by the top of the doorway.

Now we come to the door itself — the reason for my doing this painting in the first place. I had to capture the subtle texture, color, and tonality caused by the glow of the strong reflected light, if the painting was going to be successful. The wash-in stage (Plate 12) is much too crude and pale, so I had to block in the entire door very carefully with much warmer tones (Plate 13). This took some time, since special care had to be taken to get the subtle gradations on the various parts of the door — for instance, the right-hand side is receiving more light than the left, and the bottom more light than the top.

I spoke earlier of my good fortune in finding this door at the right time of day. There's another interesting fact here. If the door had been closed just a few inches more, the direct sunlight would have caused a sharply defined shadow to fall on the door from upper right to lower left. While that may have been an interesting design in itself, it would have ruined the subtle tonality of the values that had attracted me in the first place. So you can see that sometimes it's not just the time of day, but a matter of a few inches as well, that can affect a whole painting!

After I blocked in the door, I glazed down the right-hand wall to its final value (Plate 14). This was a departure from my usual procedure, which is to paint from the background to the foreground. In this case, however, I wanted to

finish the door while it was surrounded by the completed values so I could concentrate on getting just the right relationship between the door and its surroundings. If the final tones of the door had been painted while the side wall was still very light, the values could have been out of key — that is, too light or too dark in relation to the wall. At this point, even the right-hand window became a distraction. So I decided to block that in and to darken the window area, which was also attracting too much attention because it was too light (Plate 15). The windows don't look dark because of the even darker areas surrounding them, but these windowpanes are only one or two steps above the middle point on the value scale. Now all that remained to be done on the window was the detailing of the wood in the light areas and some glazing of the shadow areas. I decided to finish up the window at this point (Plate 16), so I could concentrate solely on the door.

In Plate 17, the blocked-in door has now been glazed with raw umber, which gives it the golden glow that first attracted me to it. But before I glazed it, I went through a brief period of indecision about whether or not to apply this glaze. My rule is, generally, to "glaze the shadows and opaque the lights." In this instance the door was in shadow, but at the same time it was receiving a great deal of strong reflected light. To glaze or not to glaze — that was the question. After a short debate with myself, I decided to go ahead and glaze, and when I saw the beautiful tonality it produced, I knew I'd made the right choice. Up to this point, I'd been vaguely worried about this painting. It just didn't look right somehow. The door looked raw and wasn't relating well to the rest of the painting. But once I applied the glaze, everything came together and I knew that my "mini-crisis" was over.

All that remained for me to do, then, was to detail the door and paint the black pot (Plate 18). Plates 19, 20, and 21 show details of these last steps. I then signed the painting, drank a celebration martini, and a couple of weeks later, delivered the picture to the gallery.

1. *(Right) I finish the drawing on gessoed Masonite. The iron pot was not in the original scene, but I included it to add interest. There were many such pots all over the village. This particular one came from the front of the blacksmith's shop.*

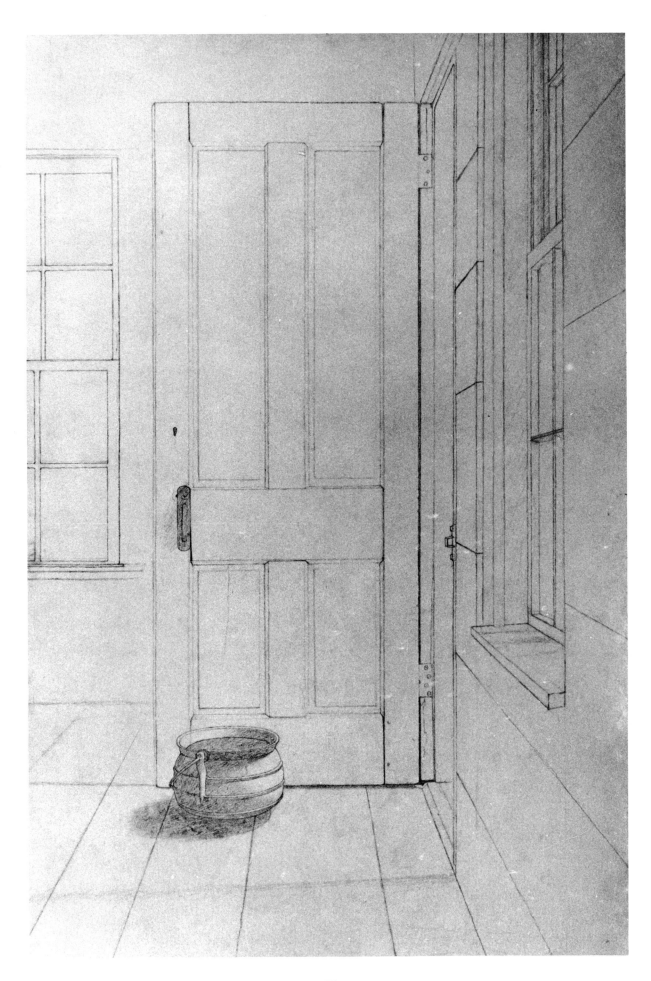

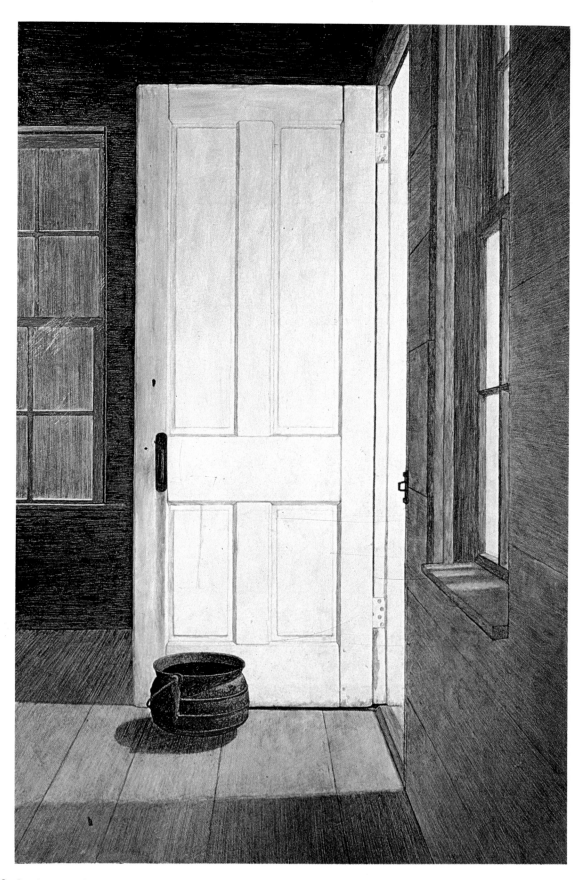

2. *In the wash-in stage, shown here, I suggest textures on the back and side walls—as is my usual practice—by dragging a bristle brush sideways while wash is wet. I eventually just glazed down these textures for the finished painting—one of the rare times when the block-in step was not needed. At this stage, the door is too light. I will darken it during the block-in stage.*

3. *For the textured wash-in of the side wall, I use straight raw umber—except on the vertical areas immediately to the left of the window, where I add a little burnt umber. The cracks between the boards are the pencil lines of the underlying drawing, which show through the wash.*

4. *For the textured wash-in of the back wall, I use straight burnt umber. Burnt umber is a darker and warmer color than raw umber. I use it here because the back wall is in much deeper shadow than the side wall.*

5. *I glaze down the back wall with straight burnt umber. The original texture just barely shows through the glaze. I add the dark cracks between the boards with a little ultramarine blue mixed with burnt umber.*

6. *I wash in the vertical boards that can be seen through the windowpanes with raw umber, adding touches of burnt sienna and cerulean blue to vary their color slightly. The boards behind the window are on the outside of the next building, just a few feet away.*

7. *I now scumble a semi-opaque light color over the windowpanes in order to give the effect of glass and push the boards on the next building back into space. Selecting this light color is a little tricky. I want a cool color, but not so cool to be out of key with the rest of the painting. I start with a mixture of raw umber and white, then keep adding more raw sienna, and end up with almost straight raw sienna and white.*

8. *Then I glaze the window-frames down in value. Notice the difference in the window-frames in this step and in Plate 6. The next building is now several feet back in space, where it belongs.*

9. *The texture of the floor at the wash-in stage is just minimal. I'll need to paint scratches and scuffmarks on top of this wash to give the effect of old worn wood.*

10. *I now block in the floor, aging it considerably. Notice that the shadows are a little lighter here as a result of the texture painted into them.*

11. *I glaze down the shadows on the floor to their final value. The dark area behind the door is a mixture of burnt and raw umber, and the foreground area is straight raw umber. The corrected shadow cast by the top of the open doorway appears on the floor for the first time.*

12. *Notice at this early stage how crudely the door is washed in. Its value is too light, its color too pale, and the drawing still shows through the wash.*

13. *I now block in the door with deeper, richer, opaque tones, paying special attention to the subtle variations of light as it falls across the door from right to left. Also at this stage, I indicate some of its texture.*

14. *I glaze down the side wall to its final value, using straight raw umber. Now, as I'm finishing the door, I can relate it properly to its surrounding values.*

15. *I block in the windowpanes and frame with darker tones next because the light windowpanes are competing too strongly with the door. The value of the windowpanes is only one or two steps above the middle value on the value scale, but it looks a lot lighter because of the very dark values around it.*

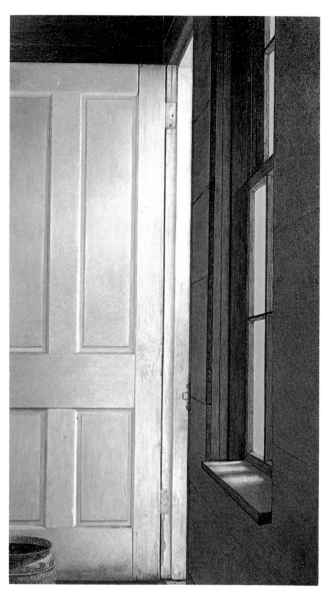

16. *To finish the side window, I glaze down the shadow areas and detail the light areas with cracks and scumbled texture. The only opaque color used on the entire window area is in the light on the windowpanes. The rest of the area consists of transparent glazes of color. With this area completed, I can now finish the door without distraction.*

17. *I glaze the door with straight raw umber, applied more heavily in the dark areas and diluted somewhat in the lighter areas. Then I daub the wet glaze with a paint rag, removing the excess color and leaving a subtle golden glow over the entire door.*

18. *I carefully apply the grain on the wooden door with a no. 8 pointed sable and then daub it with one of my old worn filbert sables (pictured on page 24) to soften it. The door is now complete.*

19. *This is a closeup of a finished midsection of the door. Sometimes a daub of my finger softens the woodgrain better than the worn filbert brush; I use both methods. The lightest lights on the door are, once again, only one or two values above middle on the value scale.*

20. *Here is closeup of the blocked-in iron pot.*

21. *I finish the iron pot by adding the highlighted texture and glazing on the shadows. The shadow of the pot on the floor was also given one more glaze at this point.*

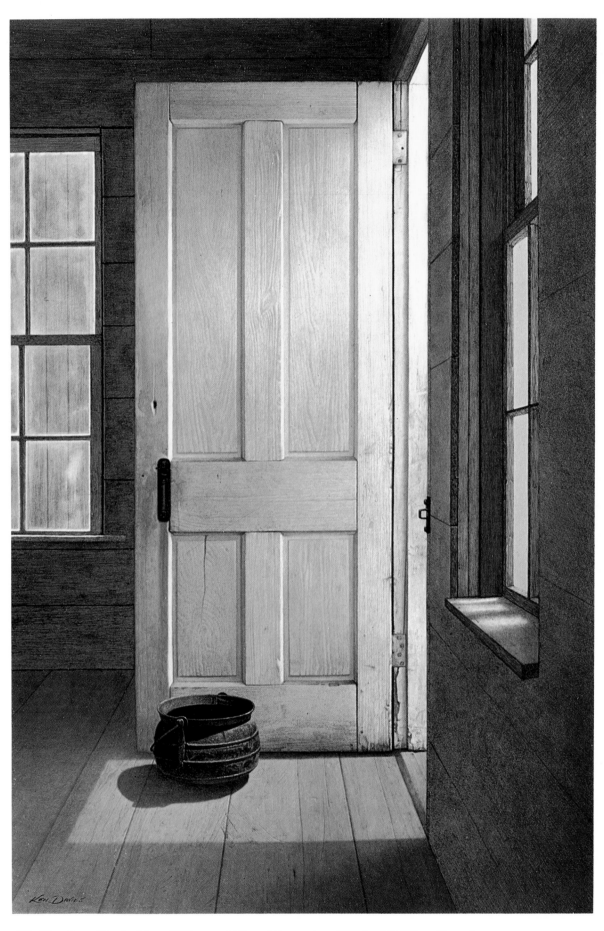

22. No. 6 at Sturbridge Village. *Oil on Masonite, 26½" x 18" (67 x 46 cm)*

Demonstration Three

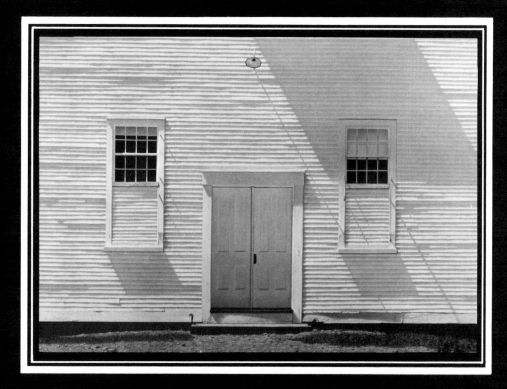

Clapboards and
Shadows

The subject of this demonstration was found in New Hampshire while visiting friends one weekend in the late sixties. It was a memorable trip for several reasons. To begin with, even though I was born in Massachusetts and lived there for my first eighteen years, until that weekend, I'd never set foot in New Hampshire. Even stranger, except for driving through the state twice on my way to Maine, I've never been back there since. This is no reflection at all on New Hampshire. It just happens to have worked out that way. However, I found more painting subjects on those two days than on any two others I can remember. Most of them were discovered in and around the magnificent old New Hampshire farmhouse in which my friends spent their summers.

The subject of *Clapboards and Shadows* was an old church or meeting house in a nearby town. I'd taken a shot of the whole building that included an interesting bell tower. The place, I thought, had some interest, but it wasn't one of those subjects that hit me between the eyes and made me want to rush home and paint it. I photographed it mainly because of my rule — "When in doubt — shoot!" As is my usual procedure, I walked up to the building and took several closeup photographs for added information. Even then I wasn't overly excited.

It wasn't until the processed slides arrived a week or so later that I noticed the potential of using just the lower part of the building, with its fascinating play of lights and shadows. I set that particular slide aside on my light table and filed the others away. It remained there until late 1976, when I finally decided to paint this picture.

That's the way it sometimes happens. For one reason or another, a painting idea can be "cooking" in the back of my mind for several years, but at other times I'll get an idea and drop everything to make a sketch — then if it works, the painting is started immediately. I can't explain exactly why this happens, but I imagine many other artists have the same experience. On the other hand, sometimes I'll start a picture, then put it aside, and it will remain unfinished against the wall for an indefinite period.

The most interesting example of the unfinished painting is one that I started over twelve years ago. I'd taken a photograph of a door on an old shack near South Beach on Martha's Vineyard. Once again, when the developed slides arrived, I got very excited about doing a painting of the door. I made a small color study and the more I got involved with it, the

more I was certain that I wanted to do a large major painting of the subject. I realized, however, that if I was going to make this a large major project, I didn't have enough information in the slide to finish it. I decided I wanted the actual door in my studio! It was then necessary to get in touch with the owner of the property for permission to remove the door. After this was done, I went to the trouble of taking a special trip to the island, taking the car over on the ferry, removing the door from the shack, tying it on the roof of my car, and driving all the way back to Connecticut with it. Keeping in mind that this was an old dilapidated door, and obviously of no practical use to anyone, it was amusing to watch the expressions of surprise and disbelief on the faces of passing motorists on the way home. I imagine that their comments must have been something about "all the strange people running around loose in the world."

At any rate, I got it safely home, set it up in the studio, and made a full-size finished drawing of the whole painting on a Masonite panel. (The size was 28" x 48" (71 x 122 cm). But that's as far as I got! I put the panel aside, got involved with other things, and haven't touched it since. The drawing is now in my attic and the actual door is *still* leaning up against the back of my garage. When I moved from Orange, Connecticut, to Madison seven years ago, I even packed it on the moving van and brought it with me. Since I haven't destroyed the drawing and thrown the door away yet, I guess that means I still haven't given up on the project. However, I have no idea at this point when I'll finish it or if I'll ever finish it. All this, of course, has nothing to do with *Clapboards and Shadows*, but it does give you a bit of an insight into the strange mind of Ken Davies.

Now, to get on with the details of painting this demonstration, it was the abstract quality of the lights and shadows that had attracted me to this subject in the first place. The composition is exactly the way I found it at that moment in time, except for one thing — the building had no shades in the windows. I first decided to add a shade on the right-hand window. This took some of the weight off the right half of the composition, which was already "overweight" due to the larger angular shadow coming down from above. I felt that the full, dark window on the left-hand side would bring a balance back to the picture, but it was some time later that I decided to add just a little of the shade on the left window too, as the extreme starkness of that one began to

bother me. If you look at Plate 8, you'll see this addition, which finally left me with a satisfied feeling about the composition.

The first step, as usual, was the drawing (Plate 1). In this case, it was rather tedious because of all the horizontal clapboards. Then (Plate 2) I did the wash-in. The light part of the clapboards at this stage is just the white of the gesso and is, of course, too cold to look like sunlight. I decided at this point to save a great deal of time by not washing in the light area of each board individually. Instead, I let the shadows dry and then washed a semi-opaque mixture of white and a little yellow ochre over the entire clapboard area (Plate 3). As you can see, this changed the tone of the shadows considerably, but since they all had to be blocked in with opaque paint anyway, it didn't matter. This way, instead of taking hours to wash in each board individually, it took just a few minutes to get the warm yellow-white tone on the light areas. The large shadow, shadows from the windowsills, and that of the door are the colors of the original wash-in.

In order to keep all the shadows consistent, I also painted the yellow-white wash over these larger shadows (Plate 4). The door and window areas are now the only ones with the original wash-

in. Also, in Plate 4, I blocked in the middle section of the clapboards. This was a very tedious, time-consuming step, so I didn't try to complete it in consecutive painting sessions, but stretched it out over a period of several days. I find that if I try to do too much of a mechanical passage such as this in one sitting, I have a tendency to rush it, and that invariably leads to sloppiness.

When I know I'll be using the same mixture of paint over an extended period of time, I mix a very large "glob" of the color (much more than I know I'll need), and leave it on my palette. Then, even though a skin forms on the outside, the inside remains wet and usable for a long time — several weeks if necessary. I used this method for the block-in mixture and also for the glaze mixture. This procedure makes it unnecessary to rematch the color at the beginning of each painting day.

I also try to keep the mixture of any color as simple as possible. The fewer the colors in any given combination, the easier it is to rematch it in case I misjudge the amount I need in the first place. I kept both of these colors throughout the painting and didn't throw them away until the day it was finished.

In Plate 5, all the clapboards and large shadows have been

blocked in. (I was very happy when that step was completed.) Plates 6 and 7 show closeups of the door and right-hand window, at that point. In Plate 8, the dark panes of the left-hand window have been finished and the windowshade, which I mentioned earlier, appears for the first time. In Plate 9, the door has finally been blocked in, and all the shadows are ready for glazing. Plate 10 is a closeup of the door at the block-in stage. Notice that the upper part of the door is a very subtle warm tone, blending down into the cooler color of the rest of the door. This is a very interesting point and, if my understanding of light, shade, and reflected light is accurate, the warm tone occurs since very little reflected light from the blue sky is hitting that area because of the overhang of the doorway. The warm reflected light from the ground, therefore, is not neutralized, as it is on the rest of the door.

Plate 11 shows most of the clapboards glazed down except for the strip across the top. The glazing of all these horizontals was just as tedious as the block-in so, again, I took several days to finish them all. Plate 12 shows a closeup of the right-hand window at this stage. I drew the pencil guidelines lightly over the large shadow areas to help me place the glaze in

the next stage. Finally, I glazed all the clapboards (Plate 13). The monotonous part was finished; the rest would be much more enjoyable.

Plates 14 and 15 show both windows before the final details were painted and Figure 16 shows the door at the same stage. Plates 17 and 18 show the finished windows and Plate 19, the finished doorway.

At this stage, except for a few details, the building was finished, and so I now turned my attention to the dirt and grass in the foreground. Plate 20 shows the left-hand side of the foreground, which is still in the wash-in stage. At one point I was tempted to put a cement or flagstone walk leading up to the doorway, but I quickly changed my mind and painted the ground exactly as I found it. After all, who was I to tell the building owners that they needed a fancy walkway to the door?

I finished the dark foundation first, since some of the pebbles and grass would extend up in front of it. The texture of the wash-in suggested the shape of some of the stones and pebbles. First, I roughly blocked in the grass area with a mixture of sap green and raw sienna. Then, I suggested blades of grass, weeds, and the like, by scraping into the wet paint with both a toothpick and several

old, worn, and hardened sable brushes of various sizes. (I usually use round, wooden toothpicks for this, sanding the points down to different thicknesses in order to vary the grass.) After this grassy area dried, I added opaque light paint to the blades of grass, which extended up in front of the foundation. The last thing that remained to be finished was the light shade at the top center, which I'd been saving as a final piece of "dessert."

I signed the painting at the lower left, on the bottom of the building. If you look closely, you'll notice that the tallest blade of grass in that whole area points directly to the signature. I must confess that this was only partially accidental, but I hope the reader will forgive my small, tongue-in-cheek display of egomania!

In 1978, this painting received the Certificate of Merit from the National Academy of Design, and I was invited to exhibit it in their galleries.

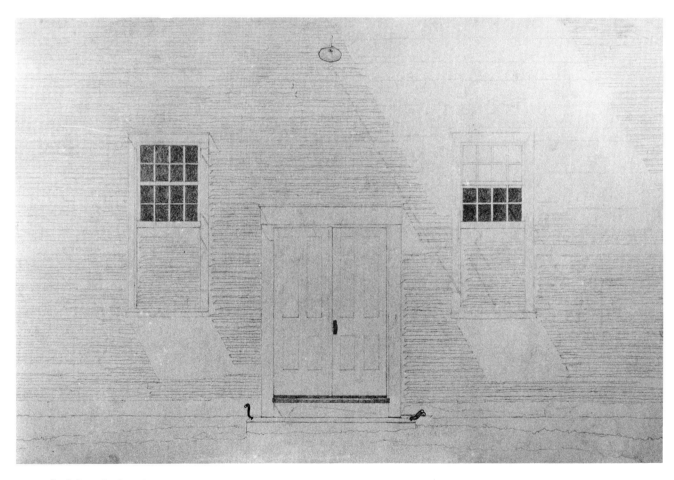

1. *I finish the drawing on gessoed Masonite. The actual building had no shades on the windows—both were like the one on the left. I added a shade on the right-hand window for two reasons. One was because I wanted to vary the two dark shapes. The other was to lighten the right side of the painting, which was heavier due to the large diagonal shadow. I felt that adding the shade would lighten the area, thus keeping it more in balance with the left side.*

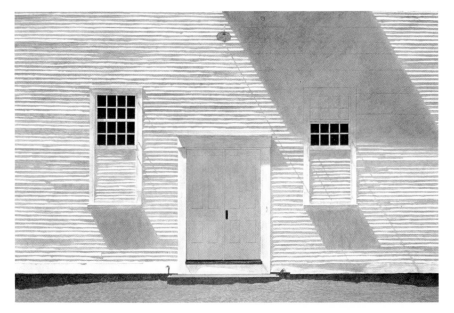

2. In the wash-in stage, I paint all the shadows with a thin mixture of cobalt blue and raw umber. I leave the light areas unpainted—they're still white gesso. The ground in front of the building is roughly textured by daubing it with a bristle brush while the wash is still wet. This texture will eventually be turned into grass and pebbles.

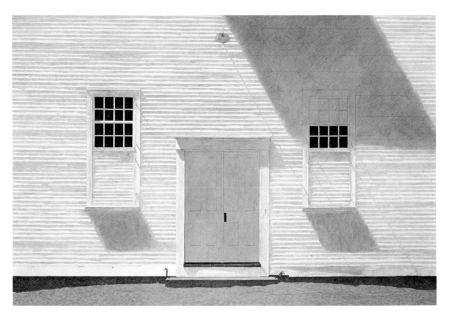

3. I add the effect of the light by painting a thin mixture of white and yellow ochre over the whole clapboard area. Only the large shadows and the doorway are the original wash-in. This white-yellow mixture adds the warm glow of sunlight to the lighted areas, as opposed to the coldness of the raw, bluish white gesso.

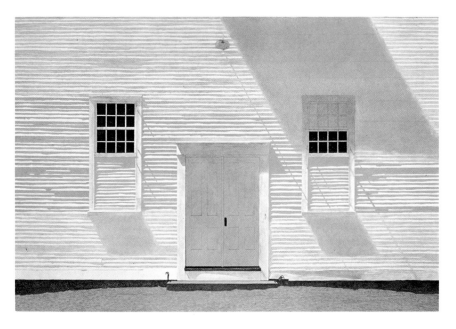

4. Now I paint the larger shadows with the white-yellow wash and block in the middle section of clapboards with an opaque mixture of white, cerulean blue, and raw umber. Notice how this block-in coat has a richer, warmer look than the milky quality of the rest of the shadows.

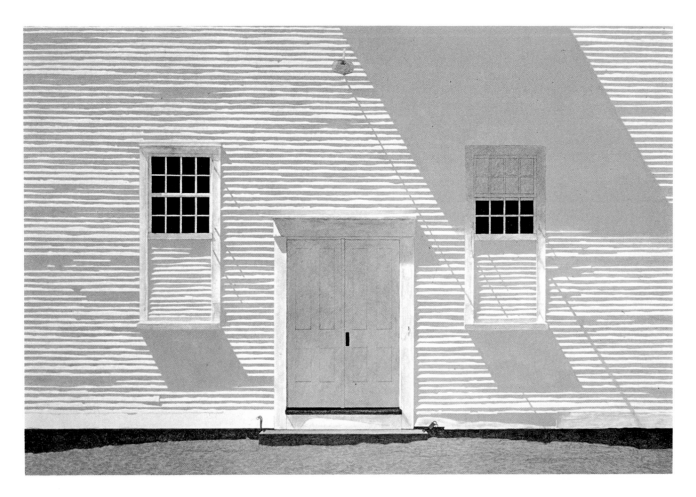

5. (Above) At this stage, all the clapboards and large shadows have been blocked in, while the doorway and window are still just washed in. The shadows are ready for glazing when the painting dries.

6. (Right) In this closeup of the right-hand window, you can see that the upper half is just washed in, while the clapboards in the lower half have been blocked in.

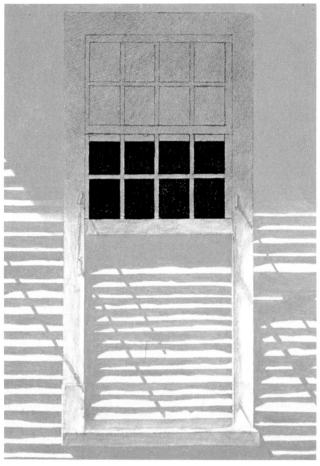

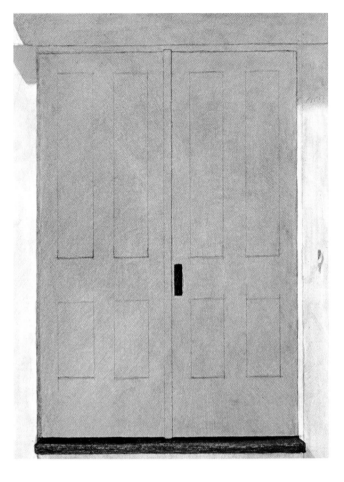

7. *This is a closeup of the doorway in the wash-in stage.*

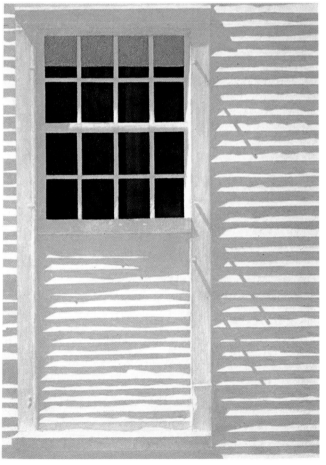

8. *This is a closeup of the left-hand window. At this point I paint the subtle reflections in the dark windowpanes. The windowshade (which was an afterthought in the total composition) and windowframe is roughly blocked in. The color of the dark window-panes is not black, but a mixture of ul-tramarine blue and burnt umber.*

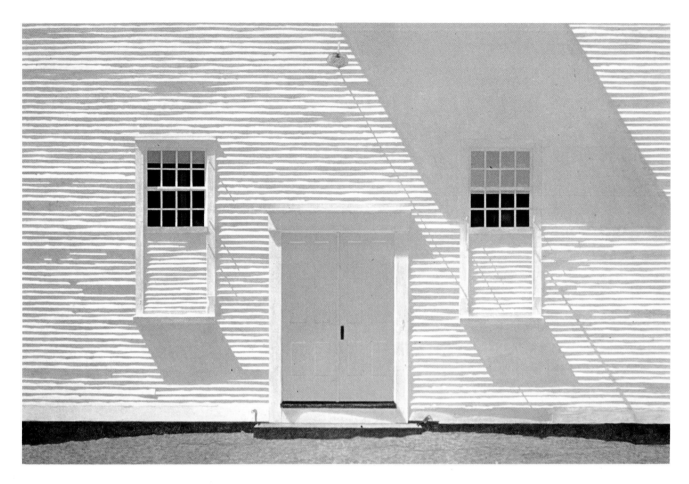

9. *I finally block in the doorway. Notice the shade in the left-hand window. If you compare this stage with the earlier one in Plate 5, you can decide for yourself whether or not the addition of the shade is an improvement.*

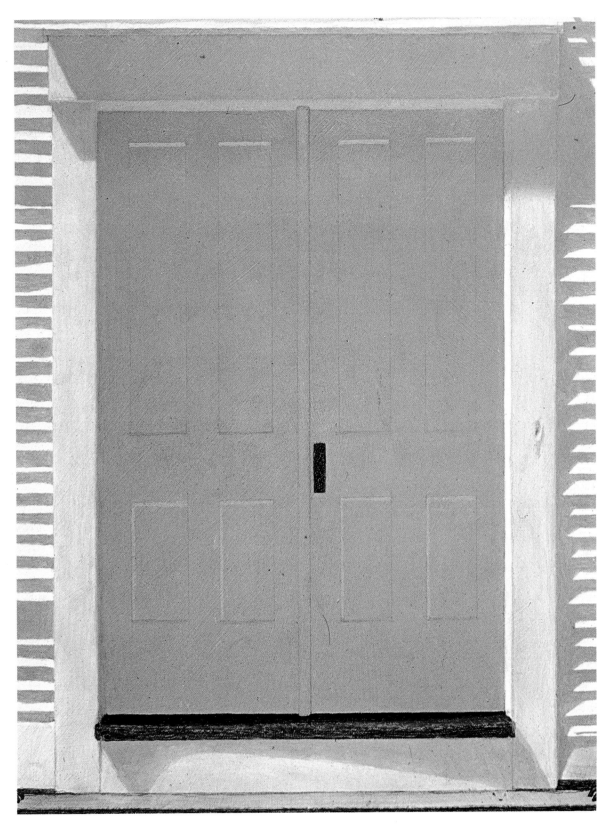

10. *In this closeup of the blocked-in door, notice that the drawing lines of the panels on the doors still show lightly through the paint. They'll act as guidelines for the final glazing and finishing steps.*

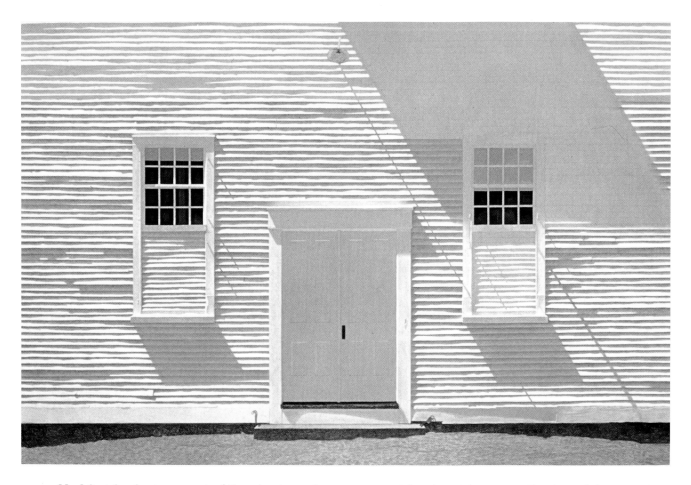

11. *I finish glazing most of the clapboards now, except for the strip across the top of the painting. Notice how the glazing extends into the large shadows and the shadows under the windows.*

12. *This is a closeup of the right-hand window, with the surrounding area partially glazed. Again, notice the pencil guidelines I placed over the blocked-in large shadows.*

13. *All clapboards now have been glazed. The doorway, step, and light are now the only parts of the building still to be finished.*

14. (Above left) The right-hand window looks like this before final detailing.

15. (Above) This is a closeup of the left-hand window before final detailing.

16. (Left) The door, before final detailing, can be seen in this closeup.

17. *(Above left) The finished right-hand window is shown above.*

18. *(Above) This is a closeup of the finished left-hand window.*

19. *(Left) This is how the finished doorway looks.*

20. *(Top) The left half of the foreground is still in the wash-in stage. I must finish the dark foundation of the building before I can paint in any grass or stones.*

21. *I now finish the foreground. Many of the stones are suggested by the original texture of the wash-in. Where the daubed texture (see Plate 2) suggests a stone or pebble, I simply paint a shadow on one side and highlight the other side with the mixture for the light area. For the light areas I use white, yellow ochre, and, in places, a touch of raw sienna; for the shadows, I generally use raw umber with a touch of raw sienna. I scratch the blades of grass out of the sap green glaze with a toothpick or an old hardened sable brush, while it is still wet. Then I add opaque color to the light areas and place shadows where they seemed to be suggested by the scratching.*

22. Clapboards and Shadows.
Oil on Masonite, 24" x 35½" (61 x 90 cm).

Demonstration Four

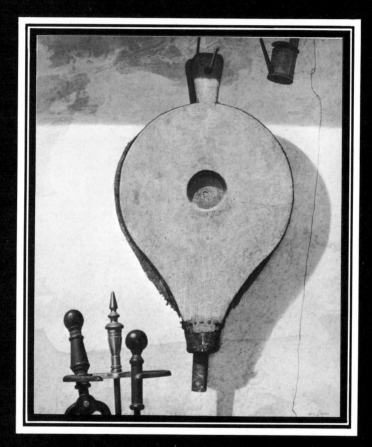

Bellows

This is another painting inspired by one of the second-year student setups at the Paier School. (I'm afraid that some day, instead of paying me a salary, Ed Paier will charge me an inspiration fee for working there.) The instructor of the class is an excellent artist by the name of Paul Lipp. He was a student of mine over ten years ago, when I used to teach the class myself, so he has a pretty good idea what props or setups I'd want to paint.

One day he came up to my office, more than usually enthusiastic about an old bellows that one of the students had brought in for her major painting. The picture that formed in my mind was one of an ordinary-size antique wooden bellows that you commonly see all the time in antique shops. I'd seen many and had even owned one at one time, but none of them had ever intrigued me enough to use in a painting. Paul insisted, however, that I had to look at this one, so I walked downstairs into the classroom with him. Contrary to what I'd imagined, the bellows that confronted me was one of monumental proportions and, without question, the most paintable one I'd ever seen. It measured 31" (79 cm) from top to bottom!

It took me all of ten seconds to decide that I had to use it. Since Paul knew what my reaction would be before I saw it, he already had started "preliminary negotiations" with the student, who was most obliging and willing to let me borrow it when she had finished her painting. It did, however, belong to her mother, who did not want to sell it (who can blame her?). So, like the cabinet in *Tea Break*, I had to carefully photograph it, since I would not be able to keep it in the studio while I painted the picture. As usual, I took many shots with light falling on it from several different angles, since I wasn't sure what angle I'd be using in the final version. Next I took several closeups of each section to be sure I had enough of the fascinating detail that covered the entire bellows.

At this point, the only thing I knew for sure was that in the finished picture, the bellows would be *actual size*. Anything smaller would have defeated the whole purpose. As a result, the size of the finished painting turned out to be 33" x 36" (84 x 92 cm)—the largest I've done in several years.

The top of the poker, tongs, and stand were the first objects to be added and, for a while, were the only additions I was considering. However, the more I studied the sketch, the more I felt the need for something else in the shadow at the upper right-hand corner.

After looking over several possible props, my eye fell on the intriguing shape that finally was included. I call it an "intriguing shape" because, at this writing, I still don't know exactly what it is! I had bought it several years ago in an antique shop and even the owner of the shop couldn't tell me what it was. I've since showed it to several other people, but with no positive results. Only part of it shows in the painting so I've included a photograph of the whole object here (right). Since there's a wick in the spout, I assume that it's some sort of lamp, but I'll be interested to find out when and how it was used and what function the circular shape at the top of the handle served.

At any rate, I added the object in my painting for balance. While trying to decide whether or not to use it, I made two very rough value sketches in pencil (Plate 1). One glance at them made me decide to include the object. The composition felt much more "comfortable" to me with it than without it. With this final decision made, I could start the drawing on the gessoed Masonite panel (Plate 2).

The wash-in step is shown in Plate 3. From the very beginning, I had decided that the bellows would be hanging against a light-textured wall. I enjoy doing these backgrounds, even though there's a certain monotony in rendering

This is the strange little lamp (I think) hanging in the upper right-hand corner of the painting. Its height, excluding the hook, is 8" (20 cm).

them. These days, I don't carefully copy the texture of actual walls or wooden backgrounds as I used to do in the early years. Though I still sometimes use a specific interesting crack, nailhole, or other shape, for the most part, these textures are a combination of my own inventions and "happy accidents" that occur during the wash-in stage. Plate 4 is a closeup of the lower right-hand portion of the washed-in wall, and Plate 5 is the same area with the finished details. If you look carefully, you can see where many of the vague shapes in the wash-in have become definite holes, cracks, and stains in the finish.

Part of the fun in doing these textured backgrounds is that, within the format of a very realistic painting, I get a chance to invent and paint totally abstract or non-objective shapes. Since my art school days, I've been fascinated by non-objective painting. However, since those days (except for my textures), I've never seriously painted one.

Plate 6 shows the same area once again with the shadow of the bellows glazed darker, finishing that section of the painting.

In Plate 7, the entire wall is detailed, including the shadows, and in Plate 8, the whole painting is shown with the background finished and shadows glazed. The wall detail in both of the shadow areas, especially in the large shadow across the top, was purposely painted with more contrast than the light areas so that it would still show through after the glaze was applied. Because of this, the whole wall in Plate 7 looks very spotty and busy. I was a little apprehensive at that point that maybe I'd overdone the detail on the wall. It's easy to get carried away with it so that, in the final painting, it becomes a distraction rather than an embellishment. But I felt much better after I glazed the area, and even better later on when the bellows and other objects had been finished.

With the wall finally completed, I could start finishing the objects. It was a relatively easy matter to paint the little tin lamp. Since it was entirely in shadow, the detail would not be as crisp and sharp as it would have been had light been falling on it, so I simply glazed the whole shape darker and suggested the detail at the same time. Plate 9 is a closeup of the washed-in lamp, and Plate 10 shows it finished.

Next I decided to block in the texture of the "main event"—the bellows. In Plate 11, the center portion of the bellows with this block-in is about three-quarters complete. This texture is a combination of shapes suggested by the wash-in and the most interesting detail on the actual bellows. In this figure, you can also see the wash-in stage of the metallic, circular center portion.

In Plate 12, the block-in of the wood and the metal circle is complete. I then took a good hard look at what I had done and decided that the whole surface of the bellows was too spotty. The value changes between the dark and light shapes had too much contrast, so I went back over the entire surface, eliminating some of the shapes and reducing the value contrast between the ones that remained. This was an extra step and one that is not usually neces-

sary; in this case, it was definitely needed. This was obviously one of those times (as I mentioned earlier) when I got carried away with my little world of non-objective shape-making.

Plate 13 shows this "corrected" block-in step almost finished. I was angry with myself for having to take the time to do it, especially since the deadline for this book was looming up in front of me ever more menacingly with each passing day! Plate 13 also shows the final glazing and detailing of the metal center. Finally, Plate 14 shows the finished dark and light accents on my "problem area."

The wash-in step on the bottom of the bellows is shown in Plate 15. This section contained the most interesting detail on the entire surface of the bellows, so here I took the time to duplicate much of it quite faithfully from the original, especially around the nails and rusted metal immediately below them. Plate 16 shows the nail area block-in and the metal finished except for final accents. In Plate 17, the entire area is finished.

The last things to be painted were the handles of the fireplace tools. Obviously, the ones pictured here are not from the same set. The brass-handled stand is from the fireplace in my livingroom and the other two are from my studio. I hope I'll be pardoned for the mismatch—my only excuse is "artistic license." I thought it was far more interesting to have different handles, and the brass handle brought a handsome touch of color into that area. I was intrigued with the color and highlights of the brass and the rugged, paintable quality of the black handles, so I simply decided to use them both. The purists can relax, though. As soon as the painting was finished, I returned everything to its proper place.

I had previously washed in the handles very roughly with flat tones (Plate 18) just to get an idea of color and value that I could relate to while painting the rest of the picture. In Plate 19 you can see three of the four steps I used in painting these objects. The cross piece on the stand and the little brass rivet on the tongs are still just washed in. The top half of the brass handle is roughly blocked in. The rest of the brass handle and the two black handles are finished, except for adding the highlights, glazing the shadows, and accenting the texture. In Plate 20, those last three steps are complete. After that, I had my usual "signing the new painting" celebration, and the finished product appears in Plate 21.

1. *These rough value sketches in pencil help me decide whether or not to use the lamp in the composition. I finally decide to use it. Do you agree?*

2. *I sketch in a final line drawing on the gessoed Masonite panel. Notice the ever-present center lines in my drawing of the handles of the fireplace tools. I always add them when I draw symmetrical objects so I can be sure both sides are exactly alike.*

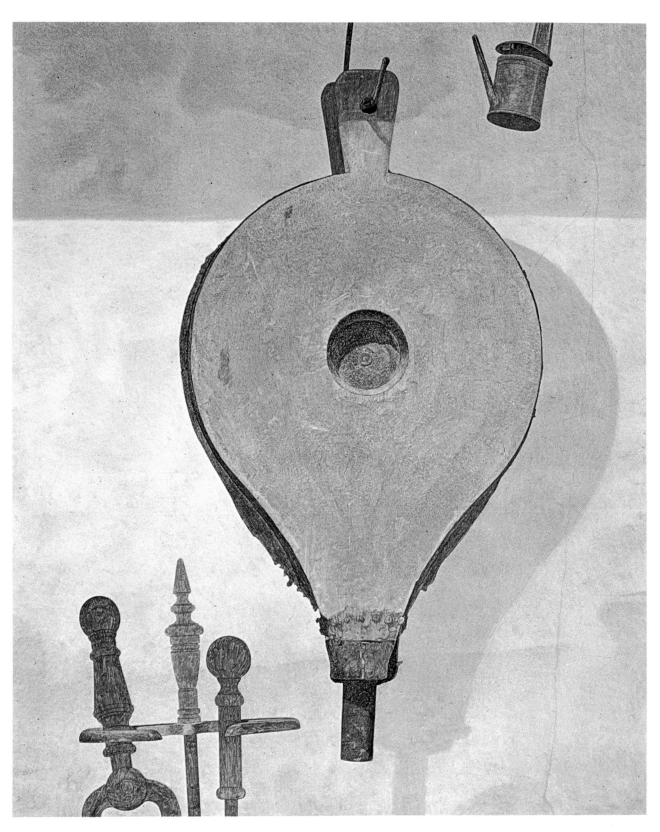

3. *The entire painting is now washed in. I paint a thin mixture of white and raw umber over the whole wall first. Then, while it's still wet, I lay in a darker mixture of raw umber and cobalt blue at random. I immediately daub the whole mess with the edge of a small kitchen sponge.*

4. *(Above) This is a detail of the lower right-hand corner of the wall in the wash-in stage.*

5. *(Above right) Here the same area is now painted with cracks, holes, and stains. Most of these are suggested by the wash-in.*

6. *(Right) I glaze the shadow of the bellows over it with a mixture of raw umber and cobalt blue.*

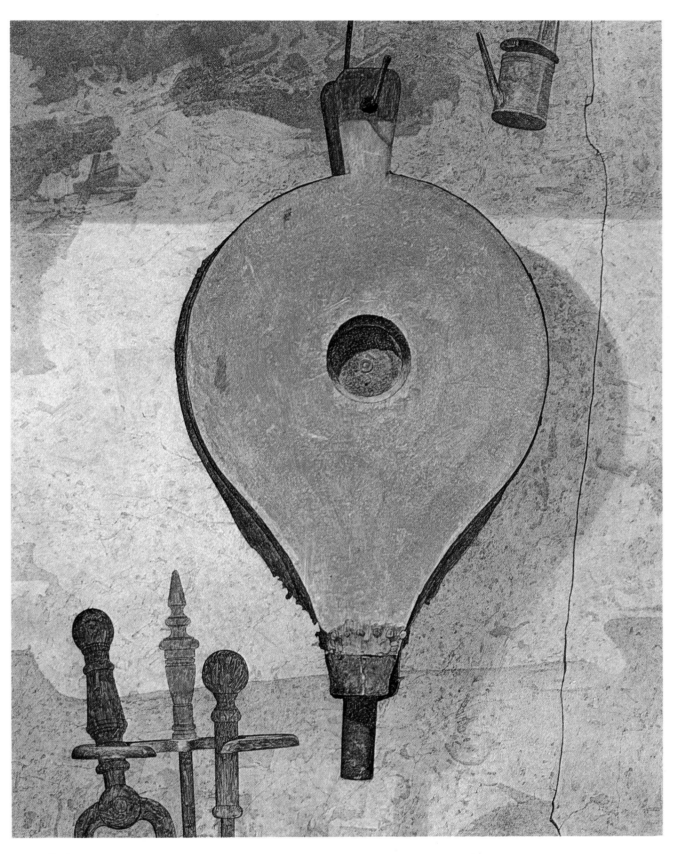

7. *Here you can see the whole painting, with the finished detail on the wall. I use a no. 8 pointed sable brush to render the small holes and scratches.*

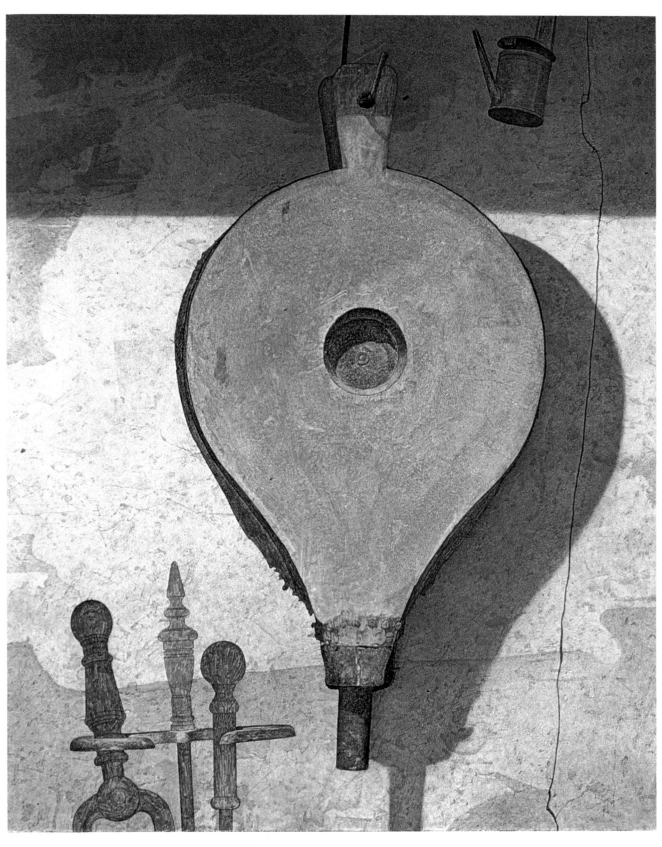

8. *This is how the painting appears at this point. The wall has now been finished and glazed.*

9. *This is a detail of the small tin lamp in the wash-in stage. Notice that the pencil lines of the original drawing can be seen through the wash. I'll use them as guidelines during the final glazing.*

10. *It took only two to three hours of painting time between the wash-in and this final step to finish the lamp. I used no opaque paint, only glazes.*

11. (Above) This is my first block-in of the texture on the central portion of the bellows. The area from about 11 o'clock to 3 o'clock is still only washed in. The metallic circle in the center is also only at the wash-in stage.

12. (Right) I now finish the block-in of the wood and metal center. I paint the wooden area with a mixture of burnt umber, burnt sienna, and white, and the metal circle with raw umber, cobalt blue, and white with touches of burnt sienna.

13. *I block in the wood on the lower portion of the bellows for the second time because I feel that the first block-in (see the upper portion) was too spotty — that is, the value contrast between the dark and light shapes is too great.*

14. *I add the final light and dark accents to the surface of the bellows. The highlights are a mixture of yellow ochre, cadmium red light, and white. I paint the dark areas with burnt umber and a touch of burnt sienna.*

15. *(Above left) In this detail of the washed-in lower portion, you can see that once again I allow the drawing to show through, especially around the nails, to aid in painting the final steps.*

16. *(Above) I block in the nail area with burnt umber, raw umber, and white, and finish the rusty metal parts, except for dark accents and small highlights. Burnt umber and burnt sienna are the predominant colors there.*

17. *(Left) The entire lower section of the bellows is finished. Notice the difference between this and the block-in step of the nail area (Plate 16).*

18. *(Above) I wash in the fireplace utensils very roughly. In this case, the pencil lines showing through are extremely important for painting the dark and light shapes of the block-in.*

19. *(Above right) This detail shows three of the four steps I used in painting the handles. I roughly blocked in the upper half of the brass handle with transparent washes of raw and burnt umber, which took one hour to paint. It took three hours to carefully render the lower half of the brass handle with opaque color: various combinations of white, raw sienna, yellow ochre, plus raw and burnt umber.*

20. *(Right) At this stage, all handles are now finished — the shadows have been glazed, all the highlights added, and the details of texture accented. Incidentally there is no black paint used anywhere on the "black" handles. I painted the handles with a combination of burnt umber and cobalt blue, with a touch of white to add opacity to the mixture. I glazed the "black" shadows with burnt umber and ultramarine blue.*

21. Bellows. *(Opposite page) Oil on Masonite, 35" x 29⅞" (89 x 76 cm).*

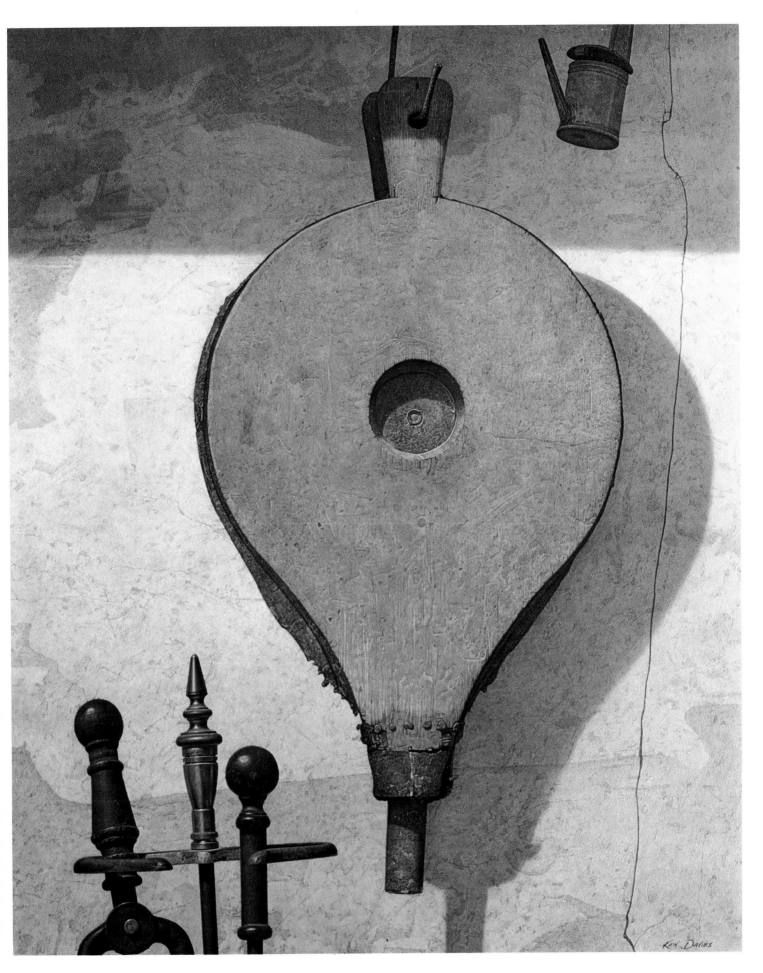

Demonstration Five

Cowbell

This painting was born in an antique shop in southern Vermont. It was there that I spotted the old bell with its great worn leather strap resting on a table crowded with all sorts of interesting objects. (That shop was a "gold mine" for me. I bought about a dozen new—well, old—exciting props there.) As I picked up the bell to examine it, I noticed an old cast iron hook on the wall above the table. Some other object was hanging on the hook, but I've forgotten what it was since I had eyes only for the hook. I hung the bell on it just as you see it in the painting and immediately became intrigued with the combined shape of the two objects. I knew I had the subject matter for a future painting. Buying the bell was no problem, but when I told the proprietor of the shop I wanted the hook also, he simply stated that it wasn't for sale, period! He was determined not to sell it, and I was equally determined to buy it. Now I have never been a good bargainer in situations like this and was obviously no match for a shrewd, old Yankee antique dealer who had obviously sized me up and decided he had a "live one." He, of course, eventually agreed to sell it, but not until I agreed to pay three or four times more than it was worth. We completed the financial transaction and I walked away from the shop knowing exactly what the old codger was thinking—"There goes another one of those damn-fool city folks willing to pay all kinds of money for a piece of junk!"

Well, I got my "piece of junk" back in the studio, where I once again hung the bell on the hook. I was still fascinated by the combination of the two shapes but realized that if I used just the two objects, I'd end up with an almost square picture, which, in this case, didn't "feel right." I subsequently decided to attach the hook to a wooden post, making a vertical picture out of it, and add "something of interest" at the bottom left. Not knowing what that would be, I went for a walk around my old house looking for the right "something of interest." I finally found it on the bottom of the doorway of my garage, which is badly in need of repair. I don't know what those two pieces of wood are there for and had never really noticed them before, but I was very happy that the old doors had not been replaced.

I then added the old rusty nail, which was not there originally. I think that the nail is a very important part of the composition. Without it, the bottom part of the painting seems a little anemic. The nail and the old rusty nailhole in the piece of wood on the left echo the color of the hook and strap and add just the right amount of "snap" to the lower portion of the picture.

This is an excellent example of making a composition "feel right," which I discussed earlier.

With the addition of the nail, the planning stage was completed and I proceeded to the line drawing (Plate 1). From the beginning, I had decided this would be one of the studies I do on illustration board where the objects are silhouetted against the white paper. I enjoy doing these "quickies" because they offer a welcome change of pace from the more involved major paintings I do on Masonite. My collection of props includes many that suit this format very well. The interesting shape of these objects with their dark value creates a striking impact against the stark white background of the board. The painting of the decoy (page 131) is another example.

When working on this paper surface, my usual block-in step is virtually eliminated. Instead, I make the wash-in as complete as possible, let it dry, and then all that is needed is the finishing step: glazing the shadows, accenting the details and texture, and painting the highlights. I use very little opaque color, generally only in the highlights. In this particular picture, except for a little opaque color on the body of the bell, in the light accents of texture, and in the highlights themselves, the entire painted surface is a transparent wash. Plate 2 shows the wash-in

stage and Plates 3 and 4 are closeups of the bell and lower left-hand corner, respectively.

During the drawing of this subject, I was not sure exactly where the left-hand and right-hand sides of the painting would be, so I left extra space on both sides. When the wash-in was completed, the value pattern was established, and then I could decide where to crop the two sides. If you compare the width of the painting in the wash-in stage to the width of the finished picture, you can see the results.

Determining exactly where to cut is an important decision. I placed two vertical strips of cardboard on either side and moved them back and forth many times before making the final choice. Sometimes a quarter or even an eighth of an inch (6 or 3 mm) more or less on either side can make the difference between the "feel wrong" and the "feel right" point. (You may enjoy trying to crop this picture yourself. Did I crop it in the "right" spot?)

Plates 5 and 6 are closeups of the finished bell and wood. As you can see, except for the finishing details and accents and the like, there is not too much difference between the wash-in and finish. Plate 7 shows the final product. The gallery frames these studies under glass in order to protect the uncoated paper.

1. *After making a rough pencil sketch to check the composition (not shown), I make a careful line drawing directly on the illustration board. When I'm finished, I spray it with fixative so it doesn't smear, then brush on a coat of retouch varnish on the areas to be painted, leaving the white background untouched. The retouch varnish seals the surface a bit so that the first layer of paint isn't absorbed by the paper quite so much.*

2. *This is the painting after the wash-in stage. Notice the width of the painting at this point, and compare it to the narrower width of the finished picture (Plate 7). I had planned to crop it from the beginning, but it wasn't until I had established the values of the wash-in that I could decide exactly where.*

3. *Closeup of the washed-in bell and hook. Much of the detail is suggested during the wash-in, so that after it dries, only the accenting of shadows and highlights needs to be done.*

4. *Closeup of the wash-in on the lower left-hand corner. The texture of the wood is suggested partially by the brushstrokes and also by the surface of the paper itself. The rusty nail and nail hole are added to introduce a repeat of the color of the strap and hook.*

5. *To finish the bell and hook, I use only a little opaque color — primarily in the highlight areas. Then I glaze the shadow areas on the strap and hook with burnt umber and cobalt blue, and those on the bell with raw umber and cobalt blue.*

6. *In this closeup of the finished lower left-hand corner, note that the light areas of wood are still the wash-in coat. The only opaque color here is the tiny highlight on the nailhead. Again, I glaze cracks and shadows with a mixture of raw umber and cobalt blue.*

7. Cowbell. *(Opposite page) Oil on illustration board, 20" x 15⅛" (51 x 38 cm).*

112

Ken Davies

Demonstration Six

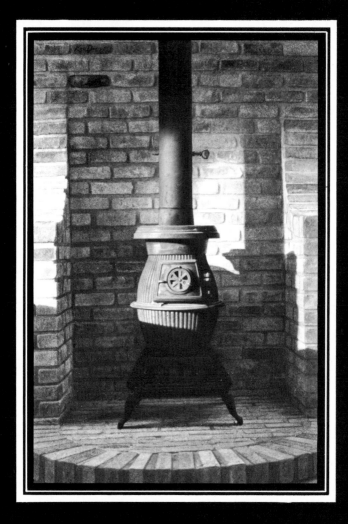

Kitchen Potbelly

B ack in December, 1973, the state of Connecticut suffered through a very severe ice storm that played havoc with power lines all over the state, leaving thousands of people without electricity. If it hadn't been for that storm, this painting would not exist.

I spent four days without power and, since I have a well, that means no heat or water. The temperature during those four days was well below freezing. Luckily this house came equipped with five fieldstone fireplaces and I had a good supply of firewood on hand. By keeping the fires going twenty-four hours a day, most of the house could be kept above 40°F (2°C). The kitchen area, however, does not have a fireplace, and at one point the temperature in there was exactly 32°F (0°C). I eventually managed to survive the crisis and got my electricity back without any damage to the water pipes. The ordeal, however, left me with no desire to go through the same experience again, and so I started to think about installing a wood-burning stove.

I discussed the problem with my friend John Calcinari, a master carpenter and cabinetmaker. In addition to his other talents, he turned out to be an excellent mason, for he designed and built the brick wall and floor, where he then installed the stove at center stage.

I had no thoughts at all of painting it until one day when I walked into the kitchen to get some lunch. I had been involved in the studio that morning and didn't stop for lunch until about 2:30 PM. The afternoon sun was streaming through the window and I spent my whole lunch hour being mesmerized by the play of light and shade around the old potbelly stove. By the time lunch was over, the shadow shapes had changed and the effect had improved. Once again, I realized that an idea for a new painting had arrived at a very unexpected time and place.

I wasn't sure which set of lights and shadows I wanted to use, so on the next sunny day, I started taking photographs at 2:00 PM and re-shot the stove every fifteen minutes. I continued this for about two hours, until the sunlight no longer fell on the stove. Each time, I took both a normal and an overexposed shot. This, of course, enabled me to capture the detail in the deep shadow areas. When the pictures were processed, I set them all on the light box and studied them at length. The longer I looked, the more I realized that no single lighting condition satisfied me completely. I preferred one area at 2:30 PM and another at 3:15 PM, and so on. Obviously the finished painting would have to be a

composite of several different times of the day. I then got out my sketchpad and made a rough pencil study (Plate 1) using different slides, taking the shapes I liked best from each, but being careful to make the whole effect believable. When the sketch was completed, I knew I had the solution. I started the finished drawing on illustration board immediately (Plate 2).

At first I intended to handle the bricks and shadow areas very loosely, and then to really detail the light area of the stove (similar to the treatment in *In the Prop Room*, page 127). However, after looking at the slides, I changed my mind and decided to wash in each brick individually and then glaze over all of them. In Plate 3, the bricks are washed in, but most of the mortar in-between is still white board. At this point, the painting looked absolutely terrible to me and I began to wonder a little whether I'd made the right choice in handling the bricks. However, I felt much better when the mortar was added (Plate 4). I then felt confident that the painting would work as I'd planned. The color of the bricks was deliberately exaggerated in the shadow areas, as I intended to glaze over them with a mixture of raw umber and cobalt blue. This is a cool, greenish color that would neutralize them a bit.

The next step was to wash-in the stove (Plate 5). I then let the whole painting dry for a couple of days before facing the most crucial two hours of the entire painting — glazing all the shadow areas on the bricks. It was the moment I'd been looking forward to during the tedious washing in of the individual bricks when the whole painting looked so awful. I would shortly know for sure whether or not the picture was going to be successful.

The glaze went on smoothly and without incident. When it was finished, I stepped back to examine the results and was pleasantly startled. The effect of light falling across the bricks was exactly what I had hoped for from the beginning (Plate 6).

After that, finishing the painting was like coasting downhill. A closeup of the washed-in stove is shown in Plate 7. The stove was blocked in and allowed to dry. I then added the shadow on the floor under the stove, glazed the shadows on the stove, and added detail in the light areas. Plate 8 is a closeup of the finished stove.

I usually sign paintings in the lower left or right-hand corner. But there was just no place to put the signature this time, so I used the dark brick in the upper left-hand corner (Plate 9).

1. *This rough sketch incorporates several lighting effects from different time periods to establish the final composition.*

118

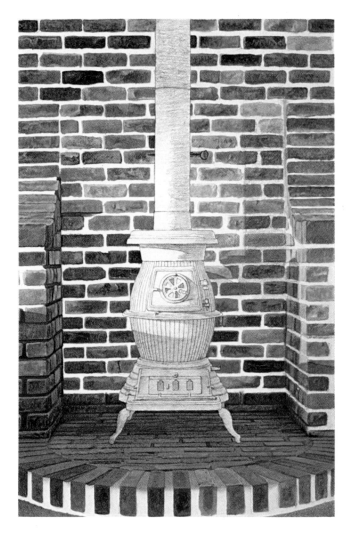

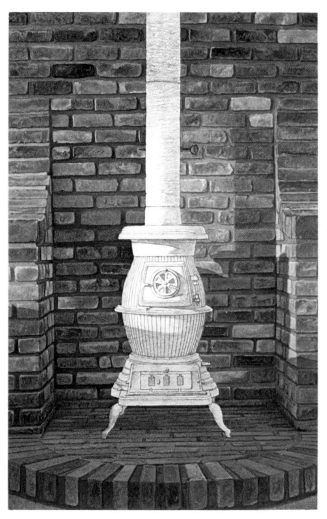

3. *I decide to wash in each brick individually (see text, page 116). But, except for the floor and the small area in the shadow at the left, all the mortar areas between the bricks are still the white paper. The painting looks terrible to me at this point.*

4. *Now the mortar has been added and the painting is beginning to look a little better, but I'm still anxious to get the glaze on over the red and crude-looking bricks.*

2. *(Left) I make a finished drawing on illustration board and spray it with fixative. Then I coat the entire surface with retouch varnish to seal it.*

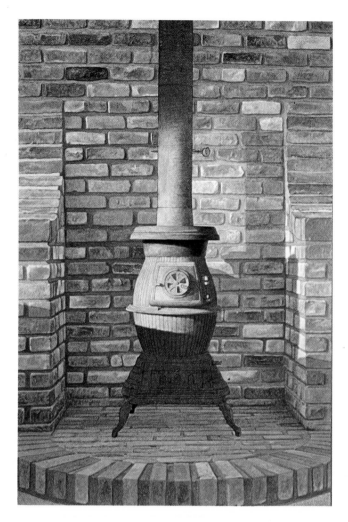

5. *I wash in the stove and stovepipe. The painting must now dry for several days before I can glaze on the shadows.*

6. *When the painting is dry, I glaze the shadows over the bricks. This adds the effect of light that attracted me to the subject in the first place. The glaze is a mixture of raw umber and cobalt blue, which helps to neutralize the red color of the bricks that I had exaggerated during the wash-in stage.*

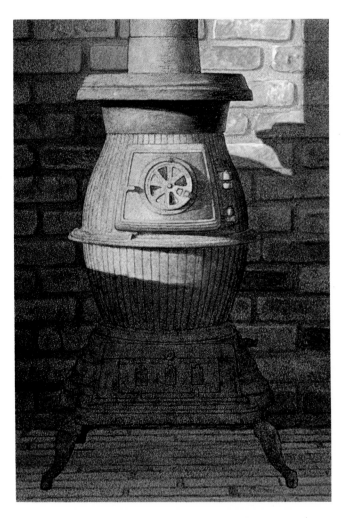

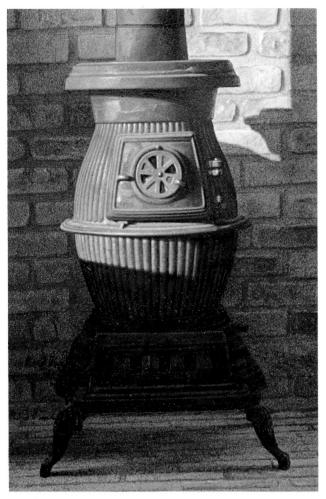

7. *As you can see in this closeup of the washed-in stove, I've allowed the drawing to show through, as usual, to aid in the block-in and finish.*

8. *This is a detail of the finished stove. The light areas on the body of the stove are composed of a simple mixture of burnt umber and white, giving the effect of warm sunlight striking the cold cast iron.*

9. Kitchen Potbelly. *(Overleaf) Oil on illustration board, 18⅜" x 12¼" (47 x 31 cm).*

121

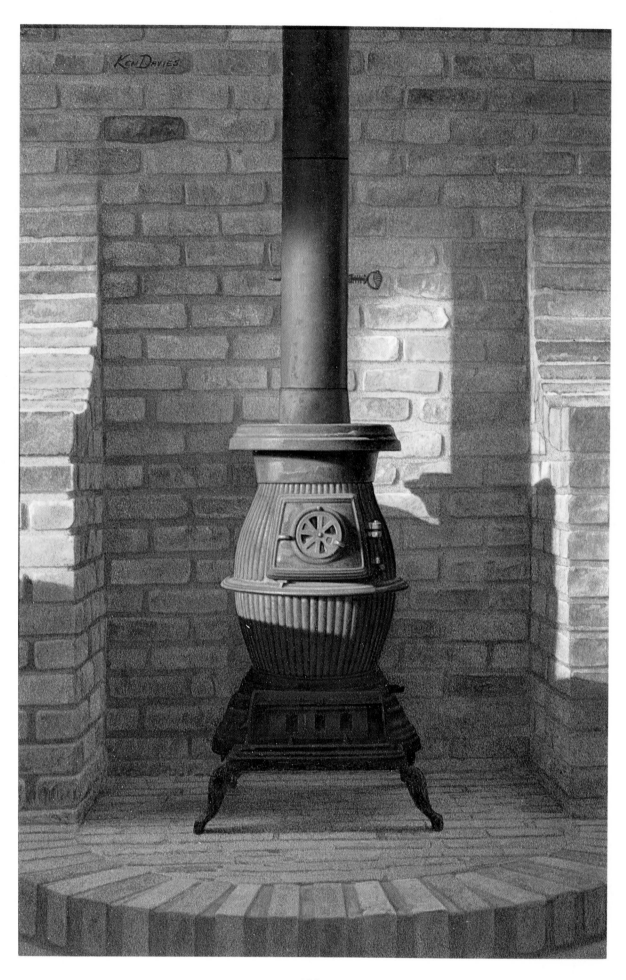

Gallery

An Egg Grader. *Oil on Masonite, 11" x 27" (28 x 69 cm). Collection of Mr. William Gray. This painting was inspired by the antique egg grader given to me by a former student. Except for the old hinge mark and the small knothole under the doorknob, which were taken from an old piece of wood, the entire background was invented. After the block-in coat was finished, I drybrushed the scuffmarks and scratches onto the dark green background by dragging the side of the brush quickly over the surface. I used both old sables and bristles in order to vary the effect. If the accidental shape that resulted was interesting, I left it, and if it wasn't, I rubbed it out and repeated the procedure until I was satisfied. The effect of rust on the egg grader itself was largely suggested during the wash-in stage and then later accented with lights and darks. The numbers, letters, and lines on the dial on top of the grader originally were drawn in with a dark pencil line that showed through the wash-in and block-in layers, and then were painted later with a fine sable brush. (This is one of several of my paintings that have been reproduced in limited-edition prints. For information and a color brochure, write to Southworth Limited, Box 902, Madison, Connecticut 06443.)*

Mail Box. *(Preceding page) Oil on board, 8" x 10" (20 x 25 cm). Private collection. This was part of a study for a large complicated major painting that never got started. Instead, I found I was much happier with the tightly framed closeup that you see here. I constantly discover picture possibilities simply by closing in on what at first glance seems like a minor part of a more elaborate composition. More often than not the result is rather striking and different, whereas the original idea would have been larger but dull.*

124

Overall Crock. *Oil on Masonite, 14½" x 22½" (37 x 57 cm). Courtesy of the Asheville Art Museum, North Carolina. This wonderful old crock was loaned to me by the same former student who let me borrow the cabinet in Tea Break. In painting the crock and little jar in front of it, I followed my usual procedure: wash-in, block-in, detailing, and glazing the shadows. (The background is one of my "non-objective texture" areas, discussed on page 90 in Demonstration Four, Bellows.) First, the wash-in of the background is roughed in with transparent color. I may then dab at it with a brush, a rag, or a sponge, or roll the side of a large round bristle over it or use anything else that I can think of to get interesting shapes and textures. When a background is in shadow, as this one is, I purposely overdo the contrast of the shapes during the wash-in — so at that stage it will look much too cluttered and busy. But when I paint a dark glaze over the entire area, this clutter is usually resolved. The result is an interesting, but not too distracting, background texture. I was very pleased when this painting was selected for the Childe Hassam Fund exhibition by the American Academy and Institute of Arts and Letters. I was even more excited when it was purchased and presented to the Asheville Art Museum in North Carolina.*

After Noon. *Oil on board, 9" x 18" (23 x 46 cm). Private collection. This stark composition is the result of a day's picture-taking trip near Southbury, Connecticut. I came upon this beautifully restored old house, complete with red barn. Buildings this well kept do not generally excite me as subject matter, since I prefer more dilapidated, weatherbeaten ones. So, I walked around admiring the place and was about to get back into my car when this doorway attracted my attention. I went up close, looked at it through the camera and, presto — this was the result.*

In the Prop Room. *Oil on illustration board, 9⅛" x 15½" (23 x 39 cm). Courtesy of Hirschl & Adler Galleries, Inc. Like Decoy (page 131), this is another form of "change of pace" painting. Some of the background shapes were suggested by furniture or props in the studio, while others accidentally "happened" during the preliminary painting. I painted the major area quickly and loosely — something I love to do but never can in a larger, more detailed painting. While the initial wash-in was still wet, I lightened some areas by wiping the color away with one of my worn filbert brushes. This procedure keeps the whole background transparent. The focal point or center of interest was then painted carefully with opaque paint. The contrast between the opaque and transparent areas produces a most interesting effect. Although paintings of this type are not always successful, the spontaneous quality of the background adds spice and excitement to the procedure.*

Milk Can. *Oil on board, 8" x 12" (20 x 30 cm). Private collection. This subject was discovered on the same day that I found After Noon (page 126). The same barn also served as a background for Fred (one of the few paintings I've done in which I included a figure. The painting is owned by the New Britain Museum and was reproduced in my first book.) Several other paintings have also resulted from that day's shooting, so the "vibrations" must have been "right." I feel this is a classic example of a "quickie" and think it's one of my best. Of course, for every one that turns out successful, there are many that end up in the trash can, but that's an occupational hazard for me when I paint this way. If these paintings take more than a few hours to complete, they're usually failures! Like my other quickies, this is 99% transparent oil wash — the only opaque color is on the highlights of the milk can.*

Cottage City Window. *(Right) Oil on illustration board, 18⅜" x 12" (47 x 31 cm). Courtesy of Hirschl & Adler Galleries, Inc. My family has owned one of the gingerbread cottages in the Campgrounds on Martha's Vineyard for years. These cottages are a constant source of inspiration and delight to me. When I first saw this striking window, the entire side of the house was covered by a mottled pattern of lights and shadows from leaves on a nearby tree. Since this made the whole thing too busy and confusing to paint, I returned on a much duller day, and found the more startling effect you see here. I tried to keep the blue siding clean and simple so as not to distract from the interesting shape of the window. The sheer curtain in the upper part of the window is all opaquely painted. Its see-through quality is achieved strictly by a control of values.*

Decoy. *Oil on illustration board, 9" x 22" (23 x 56 cm). Private collection. These change of pace "quickies" are great fun to do. They're painted almost entirely with transparent oil washes, much like a watercolor. (The only opaque color here is on the highlights of the duck.) In fact, sometimes these studies have even been mistaken for watercolor, a medium I've never been able to handle. Like watercolor, I build up the various tones with two or more washes of color. The major difference, and to me the obvious advantage of using oil, is that the wash stays wet for the whole painting session, enabling me to manipulate the tone until I get what I want. I do, however, have to wait for each layer to dry before applying a second or third glaze. This could be a disadvantage to the watercolorist, who can apply second and third washes almost immediately. I offset that somewhat by keeping two or three of these studies going at the same time. While one is drying, I work on the others.*

Race Brook Barn. *(Left) Oil on Masonite, 34" x 27" (86 x 69 cm). Collection of Mrs. Thomas Saxe, Jr. This barn is next to a tee on the Race Brook Country Club in Orange, Connecticut. I used to drive by it every day when I lived in that town. Eventually, when I stopped to take a closer look, I was impressed with the broad expanse of the side, with the little window tucked up under the eaves, and with the brickwork of its unusual foundation. Unfortunately, you wouldn't recognize the barn today—the cupola has been removed and the sides are painted red. Even though I painted each board individually, I took great care to keep them close in value so the detail wouldn't interfere with the smooth expanse of the whole side. I added the subtle rectangle of pinkish boards to the left of the tree for design purposes. There were several thin trees in the foreground, but I eliminated all but one for the painting. The old tree on the extreme right was "transplanted" from my backyard. The snow was painted almost a flat white with a slight gray tone. I'd originally thought of leaving it the pure white of the gesso, but it turned out to be much too raw and out of key with the rest of the tones in the picture.*

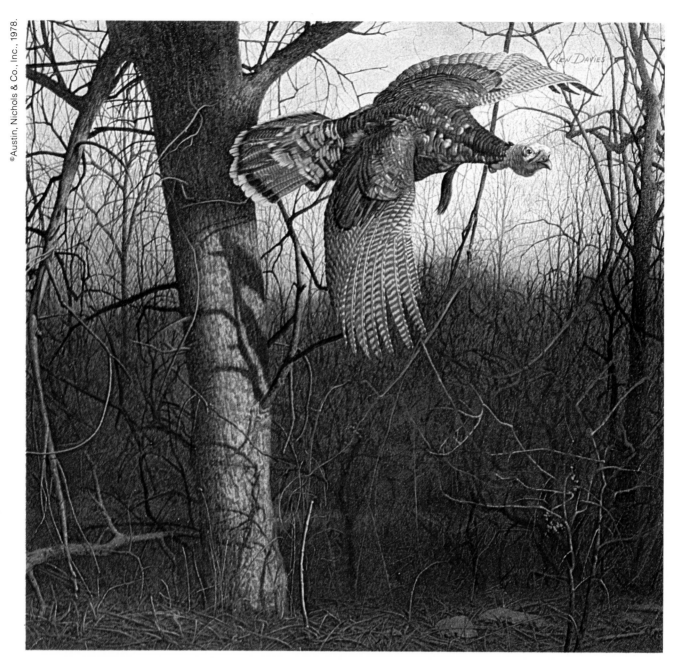

Flying Bird. *Oil on illustration board, 13½" x 14" (33 x 36 cm). Collection of Austin, Nichols & Co., Inc. This painting is the most recent of the series of wild turkeys I painted for Wild Turkey Bourbon. It is probably the best known of them all, having appeared in magazines and on billboards all over the country. At this writing, it's still being used regularly. It even appears on the label of the new Wild Turkey Liqueur. It was also the most difficult bird to paint. Believe me, it was no easy task to convince a wild turkey that he should fly past an artist's brush or his camera and assume the "correct" position from his beak to his tail feathers. After much hard work and research, I was particularly pleased with the result — especially the "no-nonsense" glint in his eye. (Permission granted by Austin, Nichols & Co., Inc. All rights reserved.)*

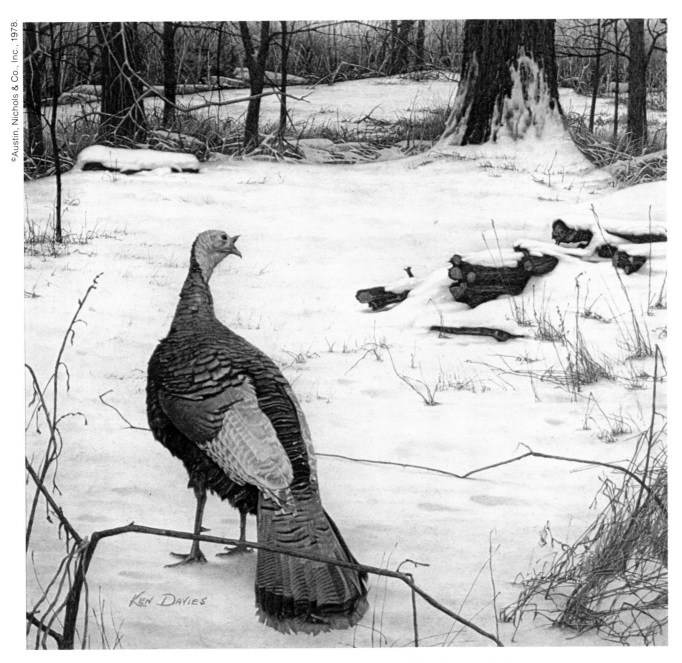

Bird in the Snow. *Oil on illustration board, 13½" x 14" (33 x 36 cm). Collection of Austin, Nichols & Co., Inc. This was the third in the series of Wild Turkey paintings. From the beginning, I was very anxious to paint the bird in the snow. I felt the subtle grays of a winter snow scene would be the perfect foil for the striking irridescent colors of the bird itself. The color of a wild turkey is truly amazing. Not only does the head change color with the mood of the bird, but the feathers really are irridescent and the color varies with the change of light. The first sketch for this painting had a solid dark wooded area across the top. It was later changed to include the field in the distance which gave the whole picture a much more open, less cramped feeling. (Permission granted by Austin, Nichols & Co., Inc. All rights reserved.)*

4:30 PM. *Oil on Masonite, 12" x 24" (31 x 61 cm). Private collection. This painting is the result of one of my photographic expeditions into the old New England community of Guilford, Connecticut. It was a late winter day and the light was beginning to fade when I came upon this barn. Everything was just as you see it except for two things: the milk can, which I added later for a spot of interest, and part of the barn, which was originally all red. I changed it to white to give the picture more snap and relieve the monotony of the large horizontal expanse of red. I painted the grass entirely in opaque color, using a small sable brush. However, in recent years, like many artists, I use a toothpick or brush handle to scratch out the blades of grass while the paint is still wet. I feel that scratching out grass has two advantages: it's much faster and, if done well, is more convincing than painting each blade of grass directly, blade by blade. When the painting was finished and I was trying to think of a title, I remembered that I'd glanced at my watch after taking the photograph. It was exactly 4:30 PM.*

Out Back. *Oil on board, 7" x 14" (18 x 36 cm). Collection of Mr. William Gray. This is another example of the right time of day making the difference between a painting and a "non-painting." I had been working out in the yard the day before discovering this and had unsuspectingly left the basket and bucket next to the cellar door. Early the next morning I discovered the intriguing pattern of light and shade that you see here. That little sliver of light falling across the foreground combined with the dark and light shapes of the building and ground is the stuff that goose-bumps are made of (at least on the back of my neck).*

White Silo. *Oil on Masonite, 16" x 20" (41 x 51 cm). Private collection. This painting was done several years ago when I was going through my "silo period." I've always been fascinated by the infinite variety in the shape of the silos attached to old New England barns, and I've painted many pictures of them. This is one of my favorites. I think the silo pictured here has a classic shape. It has a simplicity and strength, even a monumentality, that the more complicated ones don't have. The scene pictured here never actually existed. It's a composite of three different places. The barn and silo are from one location, the hay barn in the foreground is from another, and the piece of farm machinery to the right of the silo is from a third. Like 4:30 PM, this painting was done before I started to scratch out grass and hay with a toothpick or brush handle. Consequently, all the grass and hay here was painstakingly opaqued with a small sable brush and then glazed down with straight burnt umber in the darkest shadows and with a little burnt sienna added to the glaze in some of the lighter ones.*

Hartford Jug. *Oil on illustration board, 10⅛" x 16½" (26 x 42 cm). Courtesy of Hirschl & Adler Galleries, Inc. The great, simple shapes and textures of earthenware jugs have always fascinated me. This one has been on my livingroom mantel for several years. According-ing to letters incised above the flower, the jug was made by a company in Hartford, Connecticut—hence the title. I set it on a bench and used my old back door as a backdrop. To paint it, I loosely washed in the background with a semi-transparent wash. Then I painted almost the entire background and jug with varying proportions of raw umber, cobalt blue, and white. In a few areas (on the jug and cork, in particular), I added a little raw and burnt sienna. I used raw umber, burnt sienna, and a touch of white for the plant pot.*

Sheep Shed. *Oil on board, 18" x 24" (46 x 61 cm). Collection of Ethel Margolies. Red barns, in or out of the snow, have been the subject of countless paintings by countless artists over the years and I, too, have painted my share of them. However, often quite different results can occur when only a small section of the barn is used. I feel this is one of the best examples of my interest in combining abstract design with realistic rendering. Though the title tells what the building was used for, it could just as well have been titled Opus No. X with Horizontal Rectangles, or Homage to a Slightly Crooked Orange Square.*

One Moment, Please. *(Right) Oil on canvas, 26" x 34" (66 x 86 cm). Private collection. An early tongue-in-cheek picture, this is a transition between the clutter of my early work and the simplicity of some of my more recent paintings. One of the Indian cards from my childhood collection appears here for the first time. Except for the Pop Art Trompe (page 140), this is the only work in this Gallery painted on canvas. Though I've since changed my painting surface to illustration board or Masonite, my technique is still the same. After the usual wash-in, I blocked in the light areas where the paint had chipped off, and the dark areas, with flat tones. After they dried, I roughly scumbled the whole surface with a large bristle brush to eliminate that "newly painted" look. Then I added chips, scratches, and other details with a fine sable brush. Most of the texture for the back wall came from the piece of wood that served as a shelf in this painting. The word "memorandum" and the typewritten words on the paper were originally drawn in very darkly so they'd show through when I painted the paper on which they were written.*

Pop Art Trompe (Beer Can). *Oil on canvas, 18" x 24" (46 x 61 cm). Private collection. For over twenty years, I've been a member of the Silvermine Guild of Artists. Back in the late fifties, I submitted a painting to their big annual exhibition and it promptly got rejected. I think it was the first time a painting of mine had ever been rejected, so I was particularly anxious to go to the opening and see what the "good" paintings looked like. One accepted piece consisted of several crushed, rusty tin cans attached to a piece of wood. In those days, that was not a typical work of art, and so I was properly shocked. I was also annoyed at my rejection. Several weeks later, when the Guild asked its membership to donate a painting for a fund-raising art auction, my annoyance returned and I thought I would be clever and sarcastic with my donation. I decided to paint the worst non-objective painting I could think of and then to paint a very realistic crushed beer can, complete with shadow, as though it were attached to the canvas. When the painting was finished, I was rather pleased with myself. I could hardly wait to submit my masterpiece and get my revenge. I delivered it with an evil glint in my eye, then went home to await their shocked reaction. When the day of the art auction arrived and the results were announced, I was completely appalled. Not only had my horrible painting been sold, but it had brought an outrageous amount of money! I never did find out who bought it and have not seen it since. But I'd love to know where my "backfired revenge" painting is today.*

Egg Coddler. *Oil on Masonite, 9" x 14" (23 x 36 cm). Collection of Mr. and Mrs. Calder Womble. For a long time, white eggs have intrigued me as subject matter, and I've used them as a focal point in many paintings. So whenever I find an antique object that has to do with eggs, I jump at the chance to use it. This old coddler was ideal, and I've included it in several paintings. Here you see only the rack that holds the eggs—the metal container that holds the rack is not included here. I painted the background loosely and quickly with a bristle brush. Since this wash-in layer was transparent, the drawing of the foreground objects was visible through the wash. So if any of the drawing would get lost, I'd immediately wipe off the wash in that area with a rag and restate it. After the objects were blocked in and the paint had dried, I brushed a dark glaze over the entire background to lower its value. As before, while the glaze was still wet, I carefully wiped it off the objects before I continued to paint.*

Red, White, and Orange. *Oil on Masonite, 14¾" x 22⅝" (38 x 58 cm). Private collection. While cleaning out my garage several years ago, I rescued this interesting red basket from the trash heap. I took it into the studio, placed the gourds alongside, illuminated the setup with a low side light, and presto, a new painting! As I mentioned earlier, I paint under a neutral fluorescent light. But much of the time, my paintings are viewed under a warm incandescent light. Under cooler fluorescent lighting, reds and oranges tend to be somewhat neutralized, while warm lighting greatly intensifies a bright red. Since this painting had a predominance of red, I had to be careful not to let the red color get too strong. Therefore, I frequently examined it under both incandescent and fluorescent lights and tried to strike a happy medium that would look acceptable under both lighting situations.*

Index

Note: Names of paintings and pages on which photographs appear are written in *italics*.

Edited by Bonnie Silverstein
Designed by Jay Anning
Set in 14-point Memphis Light